"I have continually recommended Ronald
Davison's Planets in the Signs keyword system for
over twenty years to those who are interested in
finding a true astrological psychology—that is, to
those who want to develop astrology as a reliable
science of human nature."

—Stephen Arroyo, M.A.
Psychologist, Astrologer & Author

By the same author

Technique of Prediction
Synastry – Understanding Human Relations
Through Astrology

ASTROLOGY

The Classic Guide to UNDERSTANDING YOUR HOROSCOPE

RONALD C. DAVISON

Astrology

The Classic Guide to
Understanding Your Horoscope

CRCS PUBLICATIONS
Post Office Box 1460
Sebastopol, California 95472

Library of Congress Cataloging-in-Publication Data

Davison, Ronald C.
 Astology.

 Reprint. Originally published: New York : ARC Books,
1964, c1963. With new foreword.
 Includes index.
 1. Horoscopes. I. Title.
BF1728.A2D38 1988 133.5 87-3492
ISBN 0-916360-37-7 (pbk.)

INTERNATIONAL STANDARD BOOK NUMBER: 0-916360-37-7

Published in the United States by CRCS Publications
 Distributed in the United States by
 CRCS Publications

Published in Great Britain by Grafton Books

Contents

How to Use This Book

When we try to pick out anything by itself
we find it hitched to everything else in the universe.

— John Muir

RONALD C. Davison's contribution to astrology over the past few decades is well known to anyone who has kept up with the developments in the field through the better books and journals. Ronald Davison's books and articles cover all the major topics of modern astrology. His three books alone provide a broad survey of astrological thought and practice. *Synastry: Understanding Human Relations Through Astrology* goes into great detail about many methods of analyzing relationships; *The Technique of Prediction* is probably the most thorough explanation of secondary progressions in print; and this book *Astrology* is one of the most accessible basic interpretation books available.

In addition, Mr. Davison edited the British journal *Astrology* for many years and thereby was instrumental in keeping serious, intelligent astrology to the forefront during many years when that was indeed a challenging task. His efforts were recognized when he succeeded the eminent researcher and writer Charles Carter as President of the Astrological Lodge of the Theosophical Society. Further international recognition ensued and resulted in his being invited to do an important and well-received lecture tour in the USA.

Although today there are probably fifty times as many introductory astrology books that present the rudiments of chart interpretation as there were when this book was first published, few of them can be said to surpass the simple, yet highly accurate keyword system that Mr. Davison devised. For example, a more descriptive and insightful psychology of personal motivation than his keyword system for understanding the essence of the planets in the signs would be hard to find. The Davison keyword system is a superb learning tool for aspiring students of astrology, and it remains the outstanding interpretive tool that it was when it was one of the few intelligent systems that students had available in their initial attempts to understand this difficult art/science. Mr. Davison's insight into astrology and human

nature is proven by the fact that his keyword system remains just as valid and useful today as it was when it was first published.

During the 1960's and early 1970's, Davison's *Astrology* was often the only inexpensive text that one could find in general bookstores which presented the basics of astrology in a way that was clear, accessible, and immediately useful. Even the astrological novice can learn to deduce remarkably accurate insights into people from basic chart factors through the proper use of this book. During the 60's and 70's, this volume remained constantly in demand, and it was recommended as the best beginning guide to astrology by a number of influencial bookstores and teachers of astrology. During the heyday of the hippie generation and the accompanying rebirth of interest in ancient sciences and cosmic arts, vast numbers of people with few funds but great eagerness and sincerity in their truthseeking used this book in their initial struggling attempts to understand the inspiring mysteries of astrology. The well-known astrologer, psychologist, and author Stephen Arroyo writes:

> "I remember walking into Shambhala Bookstore in Berkeley in the late 60's and seeing stacks of Davison's *Astrology* piled about two feet high. It cost 95¢ as a small paperback, and the store couldn't keep them in stock. Since 95¢ was about all the money most of the young seekers had in those days, this was the perfect book for them, and the store's managers recommended it highly. I bought one also and began to become familiar with the keyword system. Since at the time I didn't know much astrology at all, I used the book mainly in dialogues with friends—what I might call 'joint discovery sessions.' We would look up, for example, the person's Mercury sign, and then go through the columns of keywords, constructing phrases and discussing whether these phrases indeed described the person's nature, character, motivations, needs, and so on. In an amazing percentage of cases, we would find reliable descriptions of the person I was talking with, and in fact I well remember the looks of fascination and reflection on people's faces as they revealed how impressed they were with the accuracy that this kind of astrology could provide. In fact, in numerous cases, they could not hide the strong impact made from insights into their motives and needs that they had never really considered before in that light. I have continually

recommended Ronald Davison's Planets in the Signs keyword system for over twenty years to those who are interested in finding a true astrological psychology—that is, to those who want to develop astrology as a reliable science of human nature."

One thing that makes this book remarkable is that people so often identify immediately with the keywords and phrases. However, it has been observed at times that more explicit instructions on how to use these keywords would be of great help for the new student of astrology, and that is the main purpose of this new Foreword. The heart of the book is the keyword system for understanding the sign positions of the planets (pages 35 to 78), and that is the primary focus of the examples and explanations that follow. Such key words and concepts penetrate to the *essential* meanings that people can identify with and learn from. Such abbreviated and condensed insights into personality and character, because they limit themselves only to the fundamental symbolism of the chart, are far more accurate, reliable, and useful (and far less misleading to beginners!) than the vast paragraphs of advice and purported "insights" that fill so many books and "computer horoscopes," but which somehow just never seem to really fit the individual's unique case.

In fact, Ronald Davison's keywords and phrases for planets in signs describe individual predispositions and illuminate the mystery of "human nature" far more than the vague theories, here-today-gone-tomorrow fashions, and the pseudo-knowledge of people's motives and drives that dominate modern psychology. Astrology, on the other hand, is a type of psychology, and this astrological psychology is not only based on facts and observations of millions of people over long periods of time, but—as has been shown in the research and writings of many qualified psychologist-astrologers in recent decades—it is also a psychological *science* in the true sense of the word, when astrological fundamentals are properly understood and applied. Certainly a close study of the planets in the signs section of this book cannot help but convince any open-minded inquirer of the accuracy of astrology's insights.

THE PLANETS IN THE SIGNS KEYWORDS

The value of astrology for psychological insight is most apparent in the meanings of planets in the signs. Also, the energy approach to

astrology, revealing how a birth chart can indicate the specific attunement of an individual to cosmic energies, is most apparent in and best explained by the planets in the signs. As Mr. Davison states on page 34, in most cases the *sign* positions of Jupiter, Saturn, Uranus, Neptune, and Pluto are not "strongly in evidence" unless they are tied into the chart's structure in a significant way. The sign positions of the faster moving planets (Sun, Moon, Mercury, Venus, and Mars) should therefore be the focus of attention in most cases, and always so for the new student of astrology until those planets' meanings are quite familiar.

Mr. Davison also instructs that the "Sun sign delineations may be applied to the sign ascending" as well (page 34). This is an important guideline for the student to note, since so few books give reliable descriptions of rising sign qualities and tendencies. For example, both an Aries Sun and an Aries Rising will have (see page 35):

a) the conscious aim to lead
b) a strong sense of individuality and independence (and possibly considerable egotism and rebelliousness)
c) an ability to crusade and to grasp essentials in any activity
d) an inspirational, impulsive, sometimes reckless nature
e) the need to cultivate moderation, tolerance, patience, forethought, and humility

To what extent the individual has developed each quality or ability, and to what extent he or she may express or inhibit these inborn tendencies can be determined in a *broad* way by analyzing the various other chart factors that affect the Sun (for example, aspects) or the Ascendant (for example, aspects to the Ascendant or to the "Ruling Planet" of the Ascendant). The individual's development of these tendencies can be determined *in detail* only by an in-depth dialogue with the person, and in fact it is advisable that newer students of astrology use these keywords as a learning tool by playing with their various combinations and discussing the accuracy of the results with the other person.

To take another example, if a person has Mercury in Leo (see page 48), he or she would be likely to have:

a) a creative, self-sufficient mentality that could be comprehensive and broad, but which might simply degenerate into being self-satisfied

b) an authoritative, dignified method of expression; they could even be *overly* authoritative and thus become dogmatic and overbearing

c) broad perceptions, but this could be so broad as to become hazy

d) a lack of humility and a poor capacity for handling details

It should be noted that, throughout this book, Mr. Davison uses parenthetical words to indicate the more negative expressions of the various astrological factors—in each of the sections on signs, houses, and aspects. He says, "Unless afflictions are severe and the general condition of the horoscope adverse, the comments in brackets may not apply!" The new student of astrology, however, will have no idea what is regarded in traditional astrology as "adverse" or an "affliction," and therefore such a student is advised to open-mindedly consider the accuracy of *all* the descriptive words, whether or not in parentheses. In life, positive and negative can manifest together or at least alternately in many instances, and it is realistic to assume that most people will have a broad combination of positive and negative traits, tendencies, and motives. Astrology is not an *either/or* study, but rather a subtle science that comprises an infinite variety of shadings and innumerable nuances of personality and character. For example, if Venus is in Sagittarius (page 54), let us see what keywords and phrases will apply. The person will have:

a) impulsive, sincere, unsubtle, and adventurous affections, and may be at the same time (or at least once in a while!) superficial, fickle, and flirtatious.

b) the tendency to seek harmony and pleasure through freedom, travel, and exploration, but also perhaps at times through evasive actions and/or multiple relationships.

The final example is derived from the excellent section on Mars through the signs, a planet Mr. Davison has analyzed so thoroughly that there are six different headings to be considered. Let's see what we can find for Mars in Capricorn (page 59):

a) passionate, earthy, persistent desires (of all kinds, not just sex)

b) ambition, organizing ability, and a sense of responsibility are stimulated by this position of Mars

c) efficiently controlled, sustained energy

d) a method of operation (or method of getting things done) that

could be described as practical, well-rehearsed (sometimes to the point of being unimaginative), vigorous, and prudent

e) an attitude toward life and action that is conscientious and self-reliant, but which could become dour and irritable, especially if one attempts too much

f) often a lack of humor, humility, spontaneity, consideration and warmth; this is by no means certain, and the rest of the chart could reveal all of these qualities in abundance, but it is something to at least objectively consider.

THE PLANETS IN THE HOUSES KEYWORDS

This section is far more abbreviated than the Planets in Signs section, and properly so since the planets in the *signs* reveal the real energy at work in a person and the houses are rather secondary. For example, one can do considerable accurate work in astrology using no houses whatsoever, as one must do when there is no available birth time. Nonetheless, it is a good learning exercise for new students of astrology to reflect on the keywords for each planet's house position, but just considering them to be general guidelines. These keywords should not be used rigidly but rather as a way to get a feeling for the combinations of planet and house and for the traditional astrological meanings attributed to them. But, when looking at planets in houses, as Mr. Davison states (page 85), "Due allowance should be made for the modifying effects of sign position and aspects."

It should also be pointed out that, if a planet is close to a cusp between two houses, one can use these keywords to try to discriminate between the two and thus perhaps to determine in which house a planet seems to act most strongly. Since this section focuses mainly on outer descriptive guidelines, the student should be aware that there are numerous other ways of interpreting the houses that focus more on inward reality. In other words, the brief keywords in this section by no means exhaust all interpretive possibilities!

THE ASPECTS

Ronald Davison's grouping of various planetary combinations (or planetary interchanges) focuses on the *planets* involved rather than on the type of aspect. In so many books, every particular aspect is listed (for example, all "squares" together), and readers begin to think that

all squares are "bad" or "difficult" aspects invariably, regardless of what planets are involved. But, as Mr. Davison explains, "Much, however, depends upon the intrinsic nature of the planets in aspect and upon whether they are placed in congenial signs." (page 110)

In this case also, the more negative manifestations (shown by words in parcnthcscs) can co-cxist with thc pooitivo, and a poroon with a par ticular aspect may find that a mixture of the positive and negative descriptions characterize him most accurately, no matter what precise angle separates the planets. For example, a person with *any* of the Mercury-Saturn aspects (see page 115) may have:

a) a deepened intellect with sound, methodical, conscientious, and cautious thought, although limited and stodgy in outlook at times
b) a sober, conservative attitude, with a tendency to be pessimistic, suspicious or sarcastic

One final note worth repeating is the fact that, as Mr. Davison points out on the bottom of page 117, aspects between the outer five planets, in themselves and when isolated from other primary points in the chart, are not to be given much weight. All too often, new students of astrology become very upset about, for example, a square between Uranus and Pluto, only to find out after more experience in astrology that everyone born during a period of a few years had that aspect in effect! This is just one more instance of the need for beginners in astrology to focus on the very basics, to discriminate between the primary and the secondary right from the beginning, and to realize that blending the many chart factors together effectively is an art that requires years of study and experience.

THE PUBLISHERS

ASTROLOGY
The Classic Guide to UNDERSTANDING YOUR HOROSCOPE

Introduction

THE purpose of living is to discover the purpose of living. The ancients taught that astrology was one of the keys to the solution of this enigma and somewhere in man's subconscious mind this knowledge probably lingers on, causing large numbers of human beings to consult the daily newspaper astrological forecasts which unfortunately are only a travesty of astrology. Most scientific opinion, on the other hand, inclines to the view that astrology is an outworn superstition of the middle ages. Neither of these attitudes is commendable.

Obviously mankind cannot be divided into twelve convenient groups, each having a completely identical character and destiny, which is what the newspaper forecasts imply. It is perhaps not so obvious that many of the so-called experts who have denied the validity of astrology have made no attempt whatever to study the subject, an omission that renders them liable to be charged with intellectual dishonesty!

Although astrological truth is demonstrable, man needs a rational explanation for its validity but because the real basis of astrology lies outside 'time' and 'space' in the sense that we comprehend them it is almost impossible to provide such an explanation in terms that will appeal to the materialistically minded. Astrology deals not only with the nature of things but with their latent possibilities, which are located in a dimension not apparent to our five senses.

Our conception of the Universe is apt to be drastically limited or even falsified by the imperfections of our sense perceptions. Even when we begin to realize that our senses are only capable of conveying a limited number of impressions to our consciousness we console ourselves with the thought that the marvels of modern science, such as the microscope, telescope, radio and radar, can make good the deficiencies. Yet, with all these modern discoveries, our comprehension of the Universe has not been drastically changed. Confucius taught that the greatest obstacle to hearing was the ear; the greatest obstacle to seeing, the eye, and similarly with the other senses. Plato likened the universe that man cognizes with his senses to a world of shadows, seen in a dimly illuminated cave. By such teachings the sages of earlier times sought to show that the world of phenomena

7

was only a most imperfect and highly misleading manifestation of that which lay beneath.

One of the most successful attempts to present a logical scheme in which the three dimensional world of phenomena is related to other more significant and more complete worlds was made by the Russian philosopher P. D. Ouspensky in his *Tertium Organum*. He suggested that what we regard as time is merely the result of our limitations of consciousness. Ours is a world of three dimensions, height, width and breadth. Our consciousness is only simultaneously aware of these three dimensions. Ouspensky would have us imagine that there might exist beings simultaneously aware of only one dimension. Such a dimension would be represented by a straight line. To become aware of a plane surface containing an infinite number of straight lines, these beings would have to perceive a number of straight lines successively. These perceptions would take place in what for them would appear to be 'time'. Similarly, a being aware simultaneously of only two dimensions, represented by a plane surface, could only become aware of a cube, containing an infinite number of plane surfaces, by perceiving a number of plane surfaces successively, in what for him would appear to be the passage of time. These examples suggest that time is the realm in which exists everything that we cannot simultaneously comprehend with our waking consciousness. It appears that if we could sufficiently expand our consciousness, time would cease to exist and the world of phenomena then available to us would indeed make our everyday world seem like Plato's world of shadows. We could, in fact, see simultaneously every stage in a person's life, from the cradle to the grave. If this seems far-fetched, remember that those who have been rescued from drowning have sometimes reported seeing in a matter of seconds their whole life unfold in retrospect. A sudden shock, as occultists know, can bring about startling transformations, and the heightening of consciousness is one of them.

If it is possible to reach a state of consciousness where time is virtually transcended, our whole idea of 'time' must undergo considerable modification. In his book *An Experiment with Time*, J. W. Dunne records a large number of instances where dreams were quite unmistakably either about events that happened just previously to or very soon after the dream. Thirty per cent of the dreams were about past events, thirty per cent about future events. The dream consciousness apparently draws no distinction between past and future. In the same way, a medium will sometimes confuse an event

that is about to happen to his subject with one that has just happened. Past and future, in fact, appear to co-exist but our consciousness, not in its normal state being sufficiently all-embracing, conveniently splits up our experience into past and future so that we may the more easily digest it. The present is an ever-changing point of balance between past and future and our whole life is a constant process of readjusting the interplay between the two. Eddington has said, 'Events do not happen, we come up to them'. When a young child decides he is going to be a doctor and he actually follows that profession later in life, some part of his mind has probably already made contact with the dimension that contains all events and correctly interpreted what it has seen there.

Ouspensky has shown that the line, the plane surface and the cube, which represent our three dimensions of space, have their counterparts in what we regard as 'time', which he divides into three further dimensions, the fourth: 'The line of the sequence of the moments of the actualization of one possibility;' fifth: 'The line of the eternal existence or repetition of actualized possibilities;' sixth: 'The line of actualization of all possibilities.' Because astrology deals with the world of potentials and possibilities it is related primarily to the fourth, fifth and sixth dimensions. Hence the difficulty of formulating a rational explanation of astrology that will appeal to the three dimensional awareness of man!

If we can accept the proposition that there is a level of consciousness where past and future are one, it becomes a great deal easier to see why astrology can indicate the pattern of the future. Because we know, within narrow limits, how to calculate the positions of the planets for any given point in time, we can estimate the condition of the solar system at any given moment. According to the Hermetic axiom, 'As above, so below', and the statement in Genesis that God made Man 'in his image', that is, having the same principles, it is legitimate to draw a parallel between the condition of the Macrocosm (in this case the Solar System) and Man, the Microcosm. The construction of the atom bears a close resemblance to the construction of our Solar System. When the true astrologer spoke of constellations and planets, he spoke of the constellations and planets in the soul of Man, that is, of the properties of the human soul and its relations to God and the World. The fact that there exists in the Universe a Law of Correspondences, that the Greater is reflected in the Lesser, explains why the movements of the Sun, Moon and planets have a bearing upon everything that happens in the Solar

System. Newton taught that every particle in the Universe affects every other particle. The poet Pope wrote, 'We are but parts of one stupendous whole, Whose body nature is and God the Soul.'

Rodney Collin, who closely studied the ideas of Ouspensky, has some ingenious suggestions to offer in *The Theory of Celestial Influence* as to how the Solar System can affect Man. The planets move around the Sun at varying distances from it in roughly circular orbits. The Sun is also moving in a much vaster orbit around another greater Sun, carrying with it the whole of its system. If we visualize this movement over a vast period of time we shall see that the planets are not describing circles in space but spirals. If we go back to the idea that everything happens at once and try to visualize the continuous movement of the Solar System in space we can build up a picture of a central glowing filament (the path of the Sun) surrounded by a number of coils at different distances and of various metals (according to the dominant metal in the constitution of each planet). An electrician would recognize such a picture as a representation of a polyphase transformer, presumably constructed for the purpose of stepping down the solar energy in several different ratios and transmitting it to us. Collin also shows how each of the nine main glands in the human body are related to the Sun, Moon and planets in such a way that the innermost bodies of the Solar System correspond with the central parts of the physical system and the outermost bodies correspond with those glands farthest from the centre, that is, the gonads and the pineal gland, which are farthest from the heart. In other words, it is possible to show that the situation of the main centres of man's physical system bear the same relationship to each other as the planets in the Solar System bear to each other. Each glandular centre, therefore, is probably the receiving station for one particular form of solar energy, transmitted via the transforming agency of the corresponding planet in the Solar System.

It has been observed that maximum sun-spot activity takes place (with corresponding violent electrical disturbances in the earth's upper atmosphere that have a noticeable effect upon our weather and upon short-wave radio transmissions) when Mars, Jupiter and Saturn are either in a straight line or at right angles to each other, positions recognized in astrology as producing the maximum amount of stress! Sun-spots have been described as the most powerful ultra-short-wave radio stations known, their power being much more than a million kilowatts. Rodney Collin has written, 'Electronic radiation

from the heavenly bodies produces molecular change in the Earth's atmosphere, while such molecular change in the atmosphere in turn produces cellular change in the organic bodies dwelling therein'. Such cellular change must also affect the glands, and the behaviour of these organs is recognized by psychologists as having a bearing upon human behaviour. The effect of the Moon on the tides is well known and the combined pull of the luminaries, occurring at the New and Full Moon is recognized as having the greatest effect upon the oceans of the world. As man's blood closely resembles sea-water in its chemical make-up, it is difficult to resist the conclusion that it too may be subject to the 'pull' of the luminaries. Indeed, when predicting, astrologers take notice of the impact of New and Full Moon positions upon the factors present in any given horoscope. The influence of the Moon upon feminine rhythms is well known, both in relation to the menstrual cycle and the duration of pregnancy.

It has also been observed that most suicides take place during April, least during January. In April the Sun is passing through the sign Aries, known to astrologers as the sphere of impulsive, drastic action. In January the Sun is passing through Capricorn, the most reflective and self-controlled of the signs. Experiments over a period of eight years at the University of Florence have shown that the time taken by identical amounts of a concentrated solution of bismuth to form a precipitate varies at different times during the year in proportion to the annual variations in the velocity of the earth in space. Tests at a hospital near Florence have shown that the speed of the coagulation of the blood varies similarly according to the variations in the earth's velocity.

Many of the terms in everyday use in our language bear testimony to the great part once played by astrology in times when men were less blinded by materialism. We speak of 'martial' music (of the nature of Mars), of 'jovial' uncles (of the nature of Jupiter), of 'venerable' dignitaries (of the nature of Venus), of 'mercurial' and 'saturnine' characteristics of temperament. 'Lunatics' are those excessively influenced by 'luna', the inconstant Moon. The Greek word for star is 'aster', a root which survives in the words 'disaster' and 'catastrophe'. The Latin for star is 'sidus' (genitive – sideris) and is the root of our word 'consider'. Our scientific friends who decry astrology may be somewhat taken aback to realize that they cannot properly 'consider' anything without taking into account the astrological testimonies relevant to their deliberations!

One of the biggest difficulties standing in the way of a widespread

acceptance of astrology is the inference that because astrology works man can therefore have no free will. In spite of the fact that few of us bother to exercise our free will very often (Schopenhauer wrote: 'We may have free will – but not the will to use it!') we get very annoyed at the suggestion that our lives are fated. The dilemma of Fate versus Free Will is a very old one. In a recent survey conducted in America it was found that about seventy-five per cent of astrologers believed in Karma, a universal law best summed up – 'As you sow, so shall you reap'. The same proportion also accepted the idea of Reincarnation. Combining these two ideas it will be apparent that our present circumstances are due to past causes, set in motion by ourselves. The circumstances of our present life are the results of our activities in previous lives. If these present circumstances appear to be rigidly defined in such a way to appear to us as 'fated', it is the surest possible indication that our 'fate' has been brought about by the exercise of our own free will in the past. In short, the existence of what seems to be fate is the proof of the existence of free will. A most peculiar paradox!

However, there are other limitations to our freedom. Man has a physical body that is subject to natural law. No amount of free will can absolve us from allegiance to this law. Man is free only in his mind. The more we identify ourselves with our physical bodies, the more we place ourselves under the sway of natural law. The world of nature is acted upon by the rest of the planetary system, of which it is a part. Astrology, therefore, shows us in what way the laws of nature are most likely to affect our bodies. Our minds belong to a different sphere and are subject to fewer and different laws.

One of the most striking pieces of evidence in favour of astrology is the fact that those born at the same moment of time and in approximately the same place have a life pattern that is very similar. Not all cases of twin births fulfil these conditions as one twin is often some minutes older than the other. In the case of George IV and Samuel Hemming there was a close identity of birth conditions. When George IV ascended the throne, Hemming set up in business on his own. When the King married, so did Hemming. Other parallel events took place and finally both died on the same day. On the day Queen Wilhelmina of the Netherlands married only one other woman in the country was allowed to marry. She was a friend of the Queen, her name too was Wilhelmina and she was born on the same day as the Queen!

We in the West often criticize the fact that child marriages used to

take place in India. Yet those marriages often turned out more satisfactorily than marriages in Western countries, where the participants are usually left to make a free choice. In India, astrologers advised as to the compatibility of suggested partners as they approached marriageable age, thus reducing possibilities of undesirable friction to a minimum. If this practice were followed in the West the divorce rate might be considerably reduced!

A number of famous men have acknowledged the truth of astrology. Hippocrates, the father of modern medicine, said that a doctor who did not use astrology to aid him in his diagnosis and selection of a remedy was more of a fool than a physician. Kepler was one of the last of the great astronomer-astrologers. Sir Isaac Newton, when challenged by Halley (who discovered the comet bearing his name) about his belief in astrology, said: 'Sir, I have studied the subject, you have not.' C. G. Jung, the most advanced of modern psychologists, acknowledged the validity of astrology, while Einstein was most favourably impressed by an astrological treatise by a nephew of the late Dr. Adler, another leading psychologist and a contemporary of Jung and Freud.

Where did astrology come from? Although it is possible to build up a certain body of information empirically, the whole edifice of astrology is so vast that it is easier to believe that it was originally brought to man by Great Beings of superior intelligence who came to Earth to guide infant humanity as a labour of love. In ancient Egypt there was a tradition of priest-astrologer-kings who ruled long ago. Gradually the initiated ones withdrew and the accomplishments of the rulers grew less and less. Today, in many parts of the world we still find traces of this early tradition of man being ruled by exalted beings in the fanciful titles given to some monarchs. The Emperor of Japan, for instance, is known as 'The Son of Heaven'; the King of Nepal bears the titles 'God of all Creation, Sacrosanct Fount of all Honour, Five Times Godly'.

Astrology can aid our understanding of many things but its greatest value is that it furnishes us with a method of self-judgement. No man sees himself as others see him and he is tempted to discount other people's unfavourable opinions of himself as being founded on prejudice and to accept too uncritically complimentary estimates of his character that may have been intended as flattery.

In order to get the best out of astrology the student should constantly seek to expand his knowledge of the universe in which he lives. The scope of astrology is as large as life itself but because it is

the science of correspondences, of the application of cosmic principles to the minutiae of everyday living, the more we know about the department of life to which we are applying these principles, the more effective will our judgements become. The present volume deals only with genethliacal astrology; that is, the study of nativities and their relationship to the character and experiences of the individual, who in astrological parlance is called 'the native'. In the pages that follow we shall endeavour to show how the astrological principles represented by the planets may effectively be related to the study of human character and behaviour.

The Zodiac

ONCE every year the earth makes a complete journey round the Sun in a roughly circular orbit that determines the plane of the Ecliptic, as the apparent path of the Sun round the earth is called. The eight known planets, Mercury, Venus, Mars, Jupiter, Saturn, Uranus, Neptune and Pluto all revolve around the Sun in approximately the plane of the earth's orbit. Mercury and Venus are closer to the Sun than the earth is, the other planets are farther away. Because astrology is concerned with the relationship between the movements of the various members of our Solar System and what happens on earth, the movements of the Sun, Moon and planets as they revolve in their orbits are all calculated from a geocentric point of view. In order to do this it is necessary to have an agreed starting point on the circle of the ecliptic from which to measure. This starting point is the point at which the plane of the Celestial Equator, which is the earth's equator projected into space, intersects the plane of the ecliptic on the day of the Vernal Equinox.

The circle in which the planets move is called the Zodiac and is subdivided into twelve signs, each representing successive phases of experience. The reasons underlying such a twelvefold division are rooted in the geometrical laws of the world of nature and are too complicated to deal with in a work such as this. It is sufficient for the moment for the student to appreciate that astrology takes account of the fact that there are in nature four main 'elements', Fire, Earth, Air and Water, and three ways in which each of these elements can operate as initiating, consolidating or alternating agents, three modes which are called respectively Cardinal, Fixed and Mutable. The four elements, each operating in three ways according to a certain sequence, together produce the twelve signs of the Zodiac. Each group of three signs of the same element is called a Triplicity, each group of four signs of the same mode or quality, a Quadruplicity. The cycle of the Zodiac is a cycle of experience; of every type of experience needed to induce soul growth. The order of the signs is determined according to a natural sequence. The first phase of any cycle must be initiatory, therefore the first sign is a Cardinal Sign. The application of force (power) is necessary to set anything in motion. Energy is

another form of heat, which is a property of the element Fire and so the first sign is a Fire sign, as well as a Cardinal sign. That which has been started has now to be consolidated, to be fixed, made permanent. So the second sign is a Fixed sign. That which is to be made permanent must also be given solidarity, the property of Earth, so that the second sign is a Fixed Earth sign. This leaves us with the principle of alternation or the mingling of cardinality and fixedness to be expressed in the following sign. The action of heat (Fire) upon a solid (Earth) produces a gas (Air), and so the third sign is an Air and also a Mutable sign. Air or gas, through condensation precipitates liquid (Water) and so the fourth sign in the sequence is allotted to Water, the element corresponding to Emotion. There can be no emotion without relationships, either to people or things, and so the Air signs of Relationship are always followed by the Water, or Emotional signs.

We have thus established two sequences, one of elements, the other of modes. In addition, the evolutionary path indicated by the Zodiac is divided into three stages of four signs each, the Preparatory or Primitive (Primordial) in which everything is prepared for a later, more individualized manifestation in the next four signs, while the last four apply more particularly to energies manifesting at a universal level. Further subdivisions can be distinguished in which the first six signs, corresponding to Spring and Summer, relate directly to personal experience while the last six signs, corresponding to Autumn and Winter, relate to outer or group experience. Each sign has a distinctive name, symbol and glyph, which the student should learn by heart. Thus we get the pattern shown opposite.

It will be observed that each element manifests in turn in three different ways. Because of the intrinsic nature of each sign the energies denoted by the luminaries and planets, which we shall consider in the next chapter, work out in different ways according to the sign in which they are placed. Some types of energy find a more suitable expression through fiery signs, some through mutable signs, and so on. Those born with a strong emphasis on any particular sign usually identify themselves with the characteristics of that sign. The presence of the Sun, Ascendant (see p. 79), or two or three planets in a sign generally produces such an emphasis. Since the signs represent the manner in which the functions denoted by the planets express themselves, according to the nature of each sign which is determined by its place in the cosmic scheme, it follows that no one sign is 'better' than any other as far as its qualities are concerned, since the

Name	Glyph	Symbol	Mode	Element	Season	Group	Super-group
1. Aries	♈	Ram	Cardinal	Fire	Spring	Primordial	Subjective
2. Taurus	♉	Bull	Fixed	Earth	Spring	Primordial	Subjective
3. Gemini	♊	Twins	Mutable	Air	Spring	Primordial	Subjective
4. Cancer	♋	Crab	Cardinal	Water	Summer	Primordial	Subjective
5. Leo	♌	Lion	Fixed	Fire	Summer	Primordial	Subjective
6. Virgo	♍	Virgin	Mutable	Earth	Summer	Primordial	Subjective
7. Libra	♎	Scales	Cardinal	Air	Autumn	Individual	Objective
8. Scorpio	♏	Scorpion	Fixed	Water	Autumn	Individual	Objective
9. Sagittarius	♐	Archer	Mutable	Fire	Autumn	Individual	Objective
10. Capricorn	♑	Goat	Cardinal	Earth	Winter	Universal	Objective
11. Aquarius	♒	Water-bearer	Fixed	Air	Winter	Universal	Objective
12. Pisces	♓	Fishes	Mutable	Water	Winter	Universal	Objective

qualities denoted by all twelve signs are indispensable to the complete manifestation of the Universe. Whether or not the individual can express the qualities of any given sign harmoniously depends upon the capacity for response that he has developed within himself as a result of his life experience. Those who can respond efficiently at a high level to any given sign influence will express qualities that can be immediately recognized as 'desirable'. Those who respond inefficiently and at a low level will express qualities that appear to be 'undesirable'. The undesirable qualities that result from an imperfect response to some signs are, however, more generally recognizable as 'unpleasant' than those that result from an imperfect response to other signs and so the student may encounter the idea that some signs are better than others. Such an idea only appears possible when based on the narrowest of perspectives.

Let us now trace the cycle of experience as it is depicted in the Zodiac so that we can get a better idea of the twelve phases of manifestation with which we identify ourselves, according to the nature of our horoscope. The cardinal fire sign Aries represents the First Cause, the Life Principle, Pure Spirit, God the Creator, the Resurrection, Outrushing Force whose impetus is irresistible. Here the accent is on unfettered activity, primitive self-expression, the joy of being. Those who identify themselves largely with Aries therefore see themselves as leaders and pioneers. They seek activity, often of an adventurous kind and manage to pack more experiences into one lifetime than natives of some other signs might do in two or three.

Taurus, the second and fixed earth sign represents Pure Substance, Undifferentiated Matter, the Matrix which receives the impact of the Outrushing Spirit of Aries. The Matter of Taurus is precipitated from the waters of Pisces, the twelfth sign, by the fierce fires of Aries. As a fixed earth sign Taurus represents all those forces that make for stability and permanency in the universe and those who identify themselves strongly with the sign regard themselves as builders, working with and conserving the resources of the earth. They never act without reflection and then only in the light of accumulated experience.

The third sign is the mutable air sign, Gemini. It represents the result of the impact of irresistible force (Aries) on an immovable object (Taurus). The result is Motion – axial rotation as a means of adjusting what would otherwise have been an impossible clash. Air stands for Intelligence and its primary function is to enable us to adjust ourselves to our immediate environment so that we can

begin to find some meaning in existence. The interplay of Spirit (Aries) and Matter (Taurus) produces phenomena and those who identify themselves strongly with the sign Gemini are concerned with observing all types of phenomena and establishing rudimentary connections between them. They delight in exercising their intelligence and in gathering all kinds of varied impressions. They are eager to travel in order to widen their experience. Their function is to communicate facts and link them together.

The fourth sign is the cardinal water sign, Cancer. Water is a personalizing element, adding emotional content to that which was hitherto only existing as a mental concept. Cancer represents the Universal Womb, acting as a link between the first four primitive signs and the next four individual signs. The birth of the Individual Man takes place in the sphere of Cancer, the Pure Waters of Life. Without water there can be no physical growth. The sign is a cardinal (active) one and emotion is a great spur to activity. Cancer represents the Mother Principle, first expressed in rudimentary form in Taurus (matter = mutter, mother) and those who identify themselves strongly with the sign Cancer have a high regard for the family as a unit and have a well-developed protective streak. Active emotions cause them to cling tenaciously to those people or things that arouse them. They regard it as their special function to nurture and bring along everything in its embryo state and their shrewdness in spotting potentials gives them a sound business sense.

From the Universal Womb there emerges the Divine Incarnation, Spirit made manifest. The solar fire is now confined in matter, symbolizing the emergence of Individuality in all its potential splendour. This is the realm of Leo, the Fixed Fire sign, the sign of Creation made manifest. Those who are born with the sign Leo strongly accentuated have a profound urge to exercise their creative abilities and great pride in achievement. They wish to demonstrate their prowess for all to see and admire and to radiate warmth around them so as to be recognized as the sustaining force of their immediate circle.

As a result of the Divine Incarnation, the potentials of Creative Activity have to work themselves out in a multiplicity of ways to give the myriad forms of the manifest universe. Just as Pure Spirit (Aries) needs Undifferentiated Matter (Taurus) as a medium for its self-expression, so does Spirit Incarnate need Differentiated Matter as its own special field of self-expression. The mutable earth sign Virgo relates to the specialization of forms, matter organized, purified and refined into specific and recognizable things and objects. Just as Leo

represents the Ideal Man, so Virgo represents the Ideal Woman. In the sphere of activity ruled by Virgo, the Grand Plan of the Universe is carried out in detail. Those born with the sign Virgo strongly accentuated have a highly-developed sense of detail, good powers of discrimination and an appreciation of the value of sheer technical efficiency. Because the earth of Virgo is the necessary vehicle for the creative fire of Leo, there is a strong element of Service implied and the Virgo native is often imbued with the desire to serve his fellows.

Just as Gemini, the sign of elementary relationships, followed upon the first combination of Spirit and Matter, so Libra, the Cardinal Air sign, representing Ideal Relationships, follows upon the sign of the Ideal Man (Leo) and the Ideal Woman (Virgo). The seventh day of Creation was a day of rest, not in the sense of relaxing effort, but in the sense of everything being in a state of Perfect Harmony or Balance. Libra is the seventh sign and relates to Universal Harmony that should result from the marriage of Spirit and Matter. Those who are born with a strong accentuation of the sign Libra feel a great urge to co-operate with others and make adjustments and seek compromises to encourage a more harmonious atmosphere. They are great lovers of Justice as a means of striking a balance between good and evil. Service, which belongs to the sphere of Virgo suggests relationship on two different levels, and is a necessary preliminary to establishing the goodwill from which can spring the perfected relationship of Libra.

The second water sign, Scorpio, follows. Each water sign prepares the way for a new kind of manifestation. Every fixed sign represents a particular gathering together of power. The Fixed Sign Scorpio represents emotional power, the dynamic Power distilled from the Perfect Union of Libra. This power can either be used constructively to achieve Regeneration, or destructively to result ultimately and inevitably in Death. This choice is the Temptation which confronts every one of us. We can either conquer the material world, ruthlessly eliminating everything not conducive to our higher purpose, or be conquered by it and become eliminated ourselves. Those with the sign Scorpio strongly accentuated at the time of their birth will be very much aware of the intensity of the battle going on within themselves and will go to great lengths to achieve emotional control as a means of relaxing their tension. They appreciate the value of power and the need for discipline and they have an instinctive recognition of the fact that death is not a full stop but merely a transitory phase in existence.

Two thirds of the Zodiac are now completed and we are ready to start upon the last complete group of elements. The last four signs relate to the sphere of Universal values, whereas the first four are related to the Primordial or Primitive state and the second four to the individual consciousness. The ninth and mutable fire sign, Sagittarius, represents Spirit diffused in many directions to bring about Illumination. It denotes the transformation of consciousness that can spring from the true understanding of existence. As the final spiritual expression of the Life Force it represents perfect Principle. Aspiration is the keynote of Sagittarius and those who are born with this sign strongly accentuated are keen students of life who seek to gather to themselves a variety of experience over a wide range of activities in order to discover for themselves the inner meaning of life and to enable themselves to anticipate significant developments. Religion and philosophy provide a happy hunting ground for their attempts to reach greater understanding.

The material and practical cardinal earth sign Capricorn follows, representing, as the last of the earth signs, matter organized for use in its most perfect form, the final crystallization of the material universe as the embodiment of the Perfect Principle of Sagittarius. The perfected materials are now at hand for the new spiritual birth of Man, just as the opposite sign Cancer, represented the sphere in which ordinary Man came to birth. The ultimate destiny of Matter, organized and utilized according to the Father principle of Capricorn, Governing Authority, is to provide the vehicle for the Universal Man, Aquarius. Those born with the sign Capricorn strongly accentuated appreciate the value of organization and are keen to conserve their material resources and to perfect their abilities. They have an instinctive knowledge of the necessity to maintain integrity and to conform to an accepted pattern for the sake of communal well-being.

The fixed air sign Aquarius follows. As an air sign it is a sign of relationship and as a universal sign it represents Ideal Relationship between all things, manifesting as Universal Brotherhood, the Group unified by a common Ideal, and co-operation in the widest possible sense. It also represents True Knowledge arising from an intuitive understanding of First Principles and the Wisdom that results from the interplay of Perfect Principle with Perfect Form. It denotes the power that springs from Knowledge. Those born with the sign Aquarius strongly accentuated are dedicated to the search for Truth and recognize instinctively that all men are brothers.

Finally, with the Mutable Water sign Pisces we come to the end of the cycle or, more correctly to the preparation for the beginning of another cycle, for water is the element in which germination takes place as a preliminary to outer manifestation. Pisces represents emotion as a Universal Solvent, dissolving all boundaries, permeating all forms, rounding out all experience into compassionate understanding. The dissolution of boundaries results in the disappearance of forms into the limbo where takes place the ferment of decay in the realm of Chaos, from which is developed the new impetus for the coming cycle as the waters are acted upon by the heat of Aries to produce the vortex from which emerges the resurrected power to set in motion a complete new cycle of manifestation, embodying in itself the experience of the old. The dissolution of Pisces carries with it the idea of voluntary self-sacrifice as a means of providing the power for new and greater achievements. Those born with the sign Pisces strongly accentuated feel a great kinship with their fellows and have a sympathetic understanding for the sick and suffering. They realize instinctively that the manifest universe should not be taken at its face value but that there is an underlying unity between all things which they may sense even more vividly if only they can extend the boundaries of their consciousness.

We have now completed the cycle of the signs from the point of view of their cosmic significance. Each sign is linked magnetically with its opposite sign, which shows the ultimate result of the activities belonging to the sphere of the first sign. Thus we can see that the ultimate aim of the Creation (Aries) is the establishment of Perfect Harmony (Libra). The goal for Undifferentiated Matter (Taurus) is to become regenerated under Scorpio. The ultimate aim of the Geminian intelligence is enlightenment under Sagittarius. The emotional experience gained under Cancer is to lead to perfection of form under Capricorn. The birth of the Individual under Leo is for the purpose of fitting him to play his full part in the Golden Age of Universal Co-operation under Aquarius. The differentiation of form under Virgo leads ultimately to the rounding out of experience in all directions under Pisces.

The twelve signs of the Zodiac may therefore be said to constitute a blueprint of the Universe, containing in essence the totality of all possible experience. In another sense the Zodiac may be regarded as a representation of the Cosmic Man – the Macrocosm, compared to which individual man is the Microcosm, embodying the same principles on a smaller scale. Each sign represents one part or

function of the Cosmic Man. These twelve parts and functions may be applied also to individual man in the same way. If we begin with Aries, representing the head and end with Pisces, representing the feet and apportion the other parts of the body correspondingly to the intermediate signs, we shall have an alignment of signs, parts and functions as follows:

Sign	Part of Body (Exterior)	Part of Body (Interior)	Function
♈	Head	Brain	Ideation
♉	Neck	Throat	Perpetuation
♊	Shoulders, Upper arms	Lungs	Correlation
♋	Chest, Elbows	Breasts, Stomach	Assimilation
♌	Upper back, Forearms, Wrists	Spine, Heart	Individualization
♍	Abdomen, Hands	Intestines	Ramification
♎	Lower back	Kidneys	Harmonization
♏	Pelvis	Reproductive System	Elimination
♐	Hips, Thighs	Sacral Region	Inspiration
♑	Knees	Bones	Perfection
♒	Lower legs, Ankles	Circulation of Blood	Distribution
♓	Feet	Liver, Lymphatics	Dissolution

Now let us see how the glyphs and symbols of the signs synthesize and throw light upon the characteristics of the signs they represent. The glyph of Aries (♈) suggests a fountain gushing up from some hidden spring (as indeed the entry of the Sun into Aries heralds the beginning of Spring in the Northern Hemisphere, when the world of Nature 'springs' to life). It also represents the shooting forth of plant life and, by extension, the appearance of new forms on every level in response to some hidden creative force. The Ram, the symbol of Aries, unquestioningly assumes the leadership of his flock and dashes in head down (Aries rules the head) when danger threatens. The battering *ram* and the words rampagious and rambumptious suggest the uncompromising assertiveness associated with the sign. The Lamb is traditionally the animal of sacrifice and the entry of the Sun

into the first degrees of Aries, when the sign is still young, symbolizes the sacrifice of Spirit as it descends into incarnation in Matter.

The glyph of Taurus (♉) represents the unlimited potentiality (always signified by the empty circle) of the feminine principle in the universe (shown by the crescent, here lying on its back and exalted over the circle to denote absolute receptivity and the predominance of instinct). The symbol of the Bull, an animal which can either be yoked to plough the earth or goaded into dangerous activity, represents the fertility of nature and the power of natural resources placed at the disposal of the spirit. Bullion and bully are two words related to the sign. The Bull has a powerfully developed neck, the part of the body ruled by this sign.

The glyph of Gemini (♊) represents the duality of existence and the possibility of making a choice between Good and Evil through knowledge arising from the union of spirit and matter. The symbol of the Twins also conveys the same idea of duality. The twins are Castor and Pollux, one of which has as its root meaning 'pure', the other 'polluted'. Gemmation, linked with the name of the sign, refers to propagation by budding, emphasizing the connection of the sign with all young life.

The glyph of Cancer (♋) shows the same duality in its passive form, shown by the horizontal lines, but imbued with a new potentiality, shown by the small added circles, giving the idea of two seeds, from the combination of which a mature organism can grow. The symbol of the Crab, whose hard shell protects its soft interior and whose tenacious grip is like the hold of the emotional life upon man, aptly sums up the characteristics of the sign. Cancer rules the stomach and a crab is practically a walking stomach! Personality is specially related to Cancer and has aptly been described as the organ for the digestion of experience. Those subject to moods are often called 'crabbed'. The baby's protective cradle is sometimes called a 'crib'.

The glyph of Leo (♌) is a little more obscure than the previous four. It represents the serpent power (creative force) of the body in its coiled (latent) form. The lion is undisputed king in his own sphere and is noted for his great strength and ferocity when roused, as difficult to cope with as the human passions when unrestrained. Celebrities are 'lionized' or looked upon as social 'Lions'. They are the cat's whiskers! The expression 'cat's paw' also gives a clue to certain Leo characteristics. The full heat of the Sun in Leo ripens the corn for the harvest in Virgo.

The glyph of Virgo (♍) is based upon the Hebrew letter 'Mem' signifying the female principle with an added hook apparently based on the Phoenician symbol for a fish, the symbol used by the early Christians for Jesus, giving a clue to the mystery of the 'virgin' birth of Jesus. Through purity and dedication (Virgo) is the necessary condition for the birth of the 'Messiah' established in the body of the Cosmic Man. The symbol of the sign, a Virgin, is often depicted carrying a sheaf of corn, the produce of the earth, the harvest gathered in at the end of summer. Virgin is a synonym for 'pure' and 'unspoiled'. To be 'on the verge' is to be in a position of transition from one state to another, just as the sign Virgo stands immediately before the second and indrawing half of the zodiacal cycle.

The glyph of Libra (♎) represents the setting sun, showing that the essence of being is projected into the world of the 'not-self'. It also recalls the beam of a pair of scales – Libra is latin for a pound, suggesting that the self is to be weighed against the not-self and some kind of balance and equilibrium is to be struck between the subjective and objective consciousness. The sun is about to sink below the horizon, symbolizing the indrawing of the life forces after the activity of spring and high summer. The symbol of the Scales further emphasizes that the main function of the sign is to establish equilibrium and to maintain a balance between the conflicting forces of good and evil.

The glyph of Scorpio (♏) is very similar to that of Virgo, being based on the same Hebrew letter, Mem, to which is added a barb, reminding us of the sting in the Scorpion's tail, instead of the fish symbol. This barb may be regarded as Cupid's dart, emphasizing the lure of the senses. In Scorpio the female principle has now the power to destroy (ideally to make way for a new and better creation). The Phoenix, the mythical bird that was consumed by fire and rose again from its own ashes, and the soaring eagle are alternative symbols for the sign. Scorpio is a fixed water sign. Water in its fixed state is ice which shares with the scorpion an extreme susceptibility to heat!

The glyph of Sagittarius (♐) is the Arrow propelled from the bow of the Centaur, a mythical being, half man, half horse. The Horse, the symbol of intuitive mind, is directed by the understanding of man, giving the power to develop true aim. The Arrow symbolizes Aspiration, which rightly directed, can lead man to his ultimate goal.

The glyph of Capricorn (♑) represents the serpent power of the body aroused. The symbol of the Mountain Goat with the Dolphin's Tail, shows that the destiny of the sign is to rise to perfection through

experience on all levels, from the lowest depths of the sea to the heights of the mountain, where the sure-footed goat comes into his own, carrying himself with sturdy independence and living off very little. An alternative symbol is the Unicorn, the mythical enemy of the Lion, contrasting the mobilized with the latent serpent power.

The glyph of Aquarius (≈) conveys the same idea of duality as the glyphs of Gemini and Libra, the two previous air signs. Here the twin serpents show the vibrant power of Knowledge, suggesting electric waves, one inducing the other, just as an intuitive response to and recognition of Absolute Truth induces a measure of understanding and wisdom. The symbol of the Water-Bearer represents the function of the sign as the distillation of Wisdom from Knowledge, to be poured out for the benefit of all.

The glyph of Pisces (✕) represents the two halves of experience, evolutionary and involutionary, placed in opposition to each other but linked. In Pisces the missing link is to be found that will unravel the mystery of the apparently contradictory and irreconcilable character of these two halves. The two fishes that are the symbol of Pisces are creatures that are perfectly at home in the great sea of life, their natural element and the two complementary phases of experience that they symbolize are, together with the loaves of Virgo, all that is needed to feed the multitude, according to the parable.

The Planets

THE planets of the Solar System revolve around the Sun in roughly circular orbits and in approximately the same plane, so that the whole system is shaped like a disc or saucer. Including the mean orbit of the asteroids, which may well be the exploded remains of what was once a planet, the orbital distances of the planets from the Sun conform approximately to a certain formula, known as Bode's Law, which indicates a regular proportion in these distances, as far as the planets from Mercury to Uranus are concerned. Neptune does not conform to the Law. On page 28 is a list of the planets, placed in order of their proximity to the Sun, and a few facts about them:

The Solar System is a unit and each body in it is therefore a constituent of that unit. On that account we may expect each planet to perform a specific function or to represent a particular principle in relation to the whole. The name of each planet gives a clue to its nature, for each is called after the gods or goddesses of mythology. The planetary principles are not expressed equally well through all the signs. Most of the planets are best enabled to perform their function through three only of the twelve signs. Of these, one allows the planetary principle to express its positive side with least hindrance, one allows the negative side to be expressed most easily, and the third acts in such a way as to enhance the action of the planet in a special way. The signs most nearly corresponding to the positive and negative expression of a planet are said to be ruled by it; the sign in which its action is enhanced is said to be the exaltation of that planet. A planet in a sign opposite to the one it rules cannot express its function easily and is said to be in its fall. A planet in the sign opposite to its exaltation finds it difficult to perform its function without frustration and is said to be in detriment. For convenience, astrologers often refer to the Sun and Moon as 'planets'.

The outer planets, Uranus, Neptune and Pluto appear to bear an octave relationship with Mercury, Venus and Mars and are not regarded as ruling more than one sign. Some astrologers prefer not to allocate them specifically to any sign. The Sun and Moon, coupled together as positive and negative expressions of the Life Principle, rule one sign each. Planets arranged around the Zodiac according to

Planet (and Symbol)	Moons	Completes Orbit in (approx.)	Inclination of Orbit to Ecliptic	Period of Rotation on Axis	Mean Distance from Sun (million miles)	Mean Velocity in Orbit mi./sec.
Mercury (☿)	0	88 days	7° 0′	88 days	36·0	30
Venus (♀)	0	225 days	3° 24′	few weeks	67·3	22
Earth	1	365 days	0° 0′	24 hours	93·0	18½
Mars (♂)	2	687 days	1° 51′	24½ hours	141·7	15
Jupiter (♃)	12	12 years	1° 18′	10 hours	483·9	8
Saturn (♄)	9	29 years	2° 29′	10 hours	887·1	6
Uranus (♅)	5	84 years	0° 46′	10 hours	1784·0	4
Neptune (♆)	2	165 years	1° 46′	15 hours	2795·5	3
Pluto (♇)	0	248 years	17° 9′	?	3675·3	3
Moon (☽)	—	27·3 days	5° 9′*	27·3 days	—	0·63

* Mean.

their sign rulership produce a symmetrical pattern based on the order of their nearness to the Sun:

Saturn	rules	Aquarius	and	Capricorn
Jupiter	rules	Pisces	and	Sagittarius
Mars	rules	Aries	and	Scorpio
Venus	rules	Taurus	and	Libra
Mercury	rules	Gemini	and	Virgo
Moon	rules	Cancer	Sun rules Leo	

Here are the principles represented by the Sun, Moon and planets:

The Sun (Apollo)

Without the Sun there would be no life. It is the driving force behind the whole solar system. It represents Will Power, Vitality, Leadership, Creativity, the urge to Achieve, the Conscious Aim, the Essential and Inner Nature of Man. It denotes those in high authority or of noble birth. It signifies honour, glory, power, the father, the husband (in a woman's nativity). Its action is to illuminate, vitalize, individualize, stabilize, improve, elevate, integrate. When prominent it gives benevolence, dignity, authority, nobility of character or prodigality, conceit, egoism, ostentatious behaviour. It rules Leo, the sign of Creative Power in manifestation; is exalted in Aries, representing Will in Action. Its fall is in Aquarius, where co-operation and detachment are paramount, and it is in detriment in Libra, where the emphasis is on the Not-Self. Its symbol (⊙) is the circle of limitless potentiality brought to a definite focus in the point.

The Moon (Diana)

The Sun illuminates our world by day. The reflected light of the Sun enables the Moon to prevent there being total darkness during the night. Day represents the conscious mind, night the subconscious. The Moon represents Instinct and Habit, born of heredity, the Personality, Feeling, Memory, Imagination, Receptivity, Impressionability, Desire for new experience, the Domestic, Protective and Cherishing impulses. It signifies the Mother, the wife in a male nativity, the common people, sailors, women in general, shopkeepers, those whose work is connected with liquids. Its action is to personalize, make receptive, restless. When prominent it gives sensitivity, adaptability, popularity, receptivity, sympathy or if afflicted, a tendency to be passive, cautious, negative, moody, fanciful, inconstant. It rules Cancer, the sign of the Mother Principle, and is

exalted in Taurus, representing the perfect receptivity of Virgin Matter. Its fall is in Capricorn, the sign of discipline and limitation, and it is in detriment in Scorpio, where matter becomes transformed. Its symbol is the crescent (☽) representing the Moon as a lens through which the solar rays may be focused.

Mercury

Mercury, the Messenger of the Gods is always pictured with wings on his feet, to represent the speed of thought and the ceaseless activity of the mind. Mercury represents the Power of Communication, Interpretation and Self-Expression, Intelligence, Reason, the ability to perceive Relationships and to gather Facts, Mobility, Adaptability to Environment. It signifies brothers, young people, writers, travellers, speakers, students, teachers, clerks, editors, transport workers. Its action is to quicken, enliven and add mobility. When prominent it gives quick wits, ingenuity, adaptability, humour and a love of study and argument or if afflicted, a changeable, exaggerating or tricky mind, a nervous excitable temperament, quibbling, superficial and indecisive. It rules Gemini, the sign of immediate relationships (its positive expression), and Virgo the sign of discrimination (negative expression). It is in its fall in Sagittarius, where intuition is paramount, and in Pisces, where the feelings predominate. It has no sign of exaltation but is well placed in signs ruled by Saturn, which add depth to the mental processes. Its symbol is ☿, a combination of the crescent, the circle and the cross, showing receptivity resulting from the exaltation of spirit over matter.

Venus

The Roman goddess of Beauty was the representative of man's capacity for achieving Harmony, especially through mental activities, study of the Arts, and through the social graces. Venus shows the quality of the native's urge to adapt himself to others and the nature of his affections. It is a general significator of the wife in a male nativity, of young girls, those following artistic careers, florists, dealers in ornaments, finery, perfumes, confectionery or who cater in some way for those who follow the pursuit of pleasure. Its action is to harmonize, beautify, enhance, soften, pacify. When prominent it gives an affectionate, warmly sympathetic nature and an attractive, pliant personality or if much afflicted, a fondness for being admired, a flirtatious, pleasure-seeking, luxury-loving, acquisitive, lazy, irresponsible and even dissolute disposition. In its negative aspect it

rules Taurus, where placid acquiescence is the keynote, and Libra, (positive expression) the sign of Harmony. It has its fall in Scorpio, where feeling is at its most intense, and in Aries, where activity is paramount. It is exalted in Pisces, where love reaches its finest expression through renunciation. Its detriment is Virgo, where the element of calculation inhibits its proper functioning. Its glyph is ♀, the circle of spirit elevated over the cross of matter.

Mars

As the God of War, Mars represents Passion, Desire, Energy, Assertiveness, Courage, Initiative. It signifies young men, those in the armed forces or the police or who work with fire, iron or steel, surgeons, dentists, athletes, butchers. Its action is to energize, stimulate, intensify, inflame, aggravate. It rules the positive Aries, the sign of outrushing energy, and the negative Scorpio, the battleground of desire. Its fall is in Libra, where adaptability to others is the keynote, and in Taurus, where receptivity is paramount. Its action is exalted in Capricorn, where energy is disciplined through control and experience. It is in detriment in Cancer, where every passing whim can detract from its effective expression. Its glyph (♂) represents the cross of materiality orientated in a definite direction, exalted over the circle of spirit.

Jupiter

This planet has been called the greater benefic (the lesser is Venus) and represents the Higher Mind, Wisdom, Enthusiasm, Expansiveness, Optimism, Spontaneity, Willingness to gather Experience, Benevolence, Generosity. It signifies uncles, those in the professional classes, especially those connected with the Law, the Church or Universities; big businessmen, bankers, those in confidential positions. Its action is to expand, multiply, preserve and bring increase on all levels. It rules the positive Sagittarius, where desire for a wide variety of experience can lay the foundations of true wisdom, and the negative Pisces, the sign of Charity. Its fall is in Gemini, the sign of the Lower Mind, and in Virgo, where preoccupation with detail precludes expansive action. It is exalted in Cancer, the sign of protectiveness and nourishment, where its preservative qualities find their best expression. It is in detriment in Capricorn, where crystallization restricts expansiveness. Its glyph (♃) represents the crescent of receptivity rising in the East (waxing) as a focus of material activity (the cross).

Saturn

Saturn is the Tester (Satan) whose function is to perfect character through constant trials. The rings of Saturn symbolize the limitations imposed by Saturnian action that operate as a harsh external discipline until we have learnt to discipline ourselves. It represents the principle of Contraction, Crystallization, Concentration, the ability to impose Limits; Ambition, Self-Preservation, Conventionality, Caution, Pessimism, Sense of Lack, Integrity, Responsibility, Justice, Perseverance, Stability, Endurance. It represents Time, as a crystallization of Eternity. Saturn, or Satan, is thus shown as the enemy of God, who dwells in Eternity. Saturn is the planet of old age, where the life processes are slowed up. It signifies old or serious people, the father, those in responsible positions, farmers, builders, civil servants. Its action is to limit, conserve, test, deepen, perfect, inhibit, delay, restrict. It rules the negative Capricorn, where material organization and practical ambition reaches its peak, and the positive Aquarius, where detachment is paramount. Its fall is in Cancer, where it becomes hypersensitive, and Leo, where its ambition is boundless. It is exalted in Libra, showing exact Justice perfectly balanced. It is in detriment in Aries, where impetuosity is the enemy of Stability. Its glyph (♄) shows the cross of matter elevated above the crescent of receptivity, symbolically placed at the Nadir (assimilation, pull of the past).

Uranus

This planet acts to break up the crystallizations of Saturn. It represents Originality, Inspiration, Dynamic Self-Expression, Independence, Will, Inventiveness, Eccentricity, Ability to Synthesize. It signifies unusual people, inventors, electricians, those with transcendental interests or who introduce an element of novelty into the native's life. Its action is to electrify, galvanize, vivify, awaken, mobilize dynamically, innovate, shock, break down established conditions. It often works in a spasmodic, unexpected fashion. (Appropriately, its polar axis is almost at right angles to those of the other planets.) It shares with Saturn the rulership of Aquarius, the storehouse of knowledge and has its fall in Leo, where its revolutionary spirit clashes with established sovereignty. It is exalted in Scorpio, the sphere of Regeneration and Transformation and is in detriment in Taurus, where its electricity is most effectively earthed. Its symbol (♅) shows the cross of matter above the circle of spirit between the twin columns of Good and Evil.

Neptune

The God of the Oceans was allocated these domains because they symbolized the boundlessness of space. Neptune is the planet of Intuition, Hypersensitivity, Imagination. It represents the ability to transcend boundaries, Limitless Expansion, Idealism, Sympathy, Compassion, Renunciation, Self-Sacrifice, Manoeuvrability, Glamour, Illusion, Decay. It signifies those of an artistic, mystical or highly sensitive nature, those who tend the sick, criminal or mentally deranged, or who are engaged in occupations having an element of unreality – film actors, photographers; pilots; those whose work is connected with alcohol, narcotics, drugs, oil or chemicals. Its action is to loosen, to dissolve boundaries, refine, etherialize, sensitize, idealize, make intangible, expand enormously, distort, inflate. It is the co-ruler of Pisces, the sphere of Chaos and Dissolution, and has its fall in Virgo, where particularization is paramount. It works effectively through Sagittarius, the sign of Inspiration, and is inhibited in Gemini, with its emphasis upon the gathering of everyday facts. Its glyph (Ψ) shows an upward extension of the vertical of the cross (aspiration) shielded by an extended crescent (sensitivity) to produce a Trinity exalted above matter.

Pluto

The planet named after the God of Hades represents the Underworld of man's consciousness, those elements in his nature that have not yet been redeemed and integrated with the rest of his being. Pluto's eccentric orbit shows him to be not yet completely in tune with the rest of the Solar System. His function is to bring to the surface those hidden conditions that have lain dormant in the subconscious, so that they may be transformed into a new source of power. Pluto represents the urge to Transform, to Regenerate; New Beginnings; the Group as a source of Power. It signifies those who work beneath the surface, either literally, as miners, or figuratively, as psychologists and healers; those whose work deals with death or refuse; uniformed workers, underworld characters; atomic scientists, who study the changes in matter. Its action is to isolate, bring to the surface, undermine, eliminate, transmute, transform, reinforce, intensify, obsess, add a new dimension to, purge, destroy, renew, regenerate. It is the co-ruler of Scorpio, the sign of Regeneration, and has its fall in Taurus, where rigidity renders transformation hazardous. It has an affinity with Aries, the sign of Resurrection and an antipathy with Libra, for Harmony may have to be temporarily

sacrificed while the destructive and purgative forces of Pluto prepare
the way for regeneration. Its glyph (♀) shows the seed of potentiality
(the circle) poised above the crescent of receptivity elevated above
the cross of materiality.

The Sun, Venus and Jupiter are traditionally called 'benefics',
Mars and Saturn 'malefics'. This latter category should probably be
extended to include Uranus and Pluto, with Neptune as a somewhat
doubtful 'benefic'. The Moon and Mercury are neutral.

The following interpretations of the effects of the planets in each
sign of the zodiac are intended as a general guide to delineation. Due
allowance should be made for the modifying effects of house position
and aspects received. Unless the afflictions are severe and the general
condition of the horoscope adverse, the unfavourable comments
(mostly in brackets) may not apply.

The effects attributed to Jupiter, Saturn, Uranus, Neptune and
Pluto will not be strongly in evidence unless these planets are angular
or closely configured with one or more of the faster moving bodies
or unless one of them rules the sign on the ascendant*.

The Sun sign delineations may be applied to the sign ascending,
provided due allowance is made for the fact that the solar charac-
teristics apply to the native's deep inner motives, while the ascendant*
relates to his outward and visible way of expressing the qualities
within himself.

*See p. 79

THE SUN

Conscious Aim	Strong Sense of	Ability to	Nature	Cultivate
Aries Leadership	Individuality (egotism); independence (rebellious-ness).	Crusade, grasp essentials.	Inspirational Impulsive (reckless); Assertive (aggressive); Straightforward (naïve); Sporting.	Moderation, tolerance, patience, forethought, humility.
Taurus Security	Values (possessive-ness).	Build, establish, stabilize, sustain, endure.	Conservative (reactionary); Determined (obstinate); patient (stolid); placid (lethargic); deliberate (unimaginative).	Enterprise, adaptability, vision.

The Sun—*continued*

Conscious Aim	*Strong Sense of*	*Ability to*	*Nature*	*Cultivate*
Gemini Establishment of relationships.	Awareness.	Communicate, imitate, improvise, invent, reason, learn.	Adaptable (unstable); alert (impatient); experimental (restless); inquisitive (suggestible); gay (superficial); inconsistent, diffuse.	Concentration, power to listen, relax and organize, sympathy.
Cancer Emotional unfoldment.	Attachment (clannish, romanticize past).	Nurture, protect, receive impressions, economize, publicize.	Cautious (timid); emotional (moody, self-pitying); gregarious, parental (exacting); shrewd (niggling); tenacious, sensitive (touchy).	Logic, emotional stability, healthy imagination.

Leo

Creative self-expression.	Dignity (vain, imperious).	Dramatize, radiate, enjoy, inspire faith, vivify, organize.	Ardent (exuberant); magnanimous (demanding); pleasure-loving (indolent); hospitable, flamboyant (theatrical); (predatory).	Humility, thrift, altruism, attention to detail.

Virgo

Perfection, self-dedication.	Service, craftsmanship.	Analyse, criticize, assimilate, discriminate, sublimate passions, adapt.	Practical, modest, (self-conscious, puritanical); sceptical, systematic, impartial (unenthusiastic); conscientious (finicky).	Breadth of vision, tolerance, imagination, optimism.

The Sun—*continued*

Conscious Aim	Strong Sense of	Ability to	Nature	Cultivate
Libra Harmony	Beauty, justice, idealism.	Negotiate, adjust, compare.	Diplomatic (insincere); helpful (interfering); friendly (dependent); susceptible (wavering, easily influenced); contentious (Asc.) lazy (*laissez-faire*).	Firmness, decisiveness, consistency.
Scorpio Power	Self-control (repression).	Probe, eliminate, destroy, re-generate.	Incisive (ruthless); intense (fanatical); strong-willed, reserved (secretive, sus-	Forgiveness, right direction of aspiration and energy.

picious, resent-
ful);
thorough,
passionate (sen-
sual);
possessive
(jealous);
courageous.

Restraint,

sincerity,

fixity of
purpose,

thought for
others.

Sagittarius
Wisdom Perspective Explore Honest
(blunt,
transparent);
propagate, impulsive
(flighty);
react quickly, speculative
(careless);
prophesy, optimistic
(improvident,
over-confident);
establish jovial
connections, (boisterous);
versatile
(dabbling);
converse. alert
(superficial).

The Sun—continued

Conscious Aim	Strong Sense of	Ability to	Nature	Cultivate
Capricorn Integrity	Reverence, duty.	Utilize, conserve, crystallize, persevere, concentrate, climb, organize.	Fatherly (austere, severe); Just (scrupulous); Cautious (suspicious); Economical (mean); ambitious (snobbish, time-serving); dependable, self-absorbed (morbid); practical (uninspired).	Sociability, buoyancy, effective self-expression.
Aquarius Truth, knowledge.	First Principles,	Investigate,	Intellectual (doctrinaire);	Warmth,

	altruism.	co-ordinate, synthesize, plan, reform.	detached (remote); scientific (agnostic); humanitarian, unconventional (perverse, incalculable); individualistic (anarchical); expectant.	human touch, practical ability.
Pisces Understanding.	Sympathy.	Believe, permeate, renounce, sacrifice self, receive impressions.	Easy-going (lazy); plastic (unstable); imaginative, poetic (unworldly, chaotic); suggestible (hypochondriac); emotional, self-pitying.	Determination, concentration, avoidance of stimulants.

THE MOON

	Personality	Capacity for	Feelings	Instinct, Imagination
Aries	Active (restless, challenging); forceful (self-willed, militant); independent (disobedient); impetuous (unbalanced).	Enthusiasm (fanaticism).	Easily aroused (hasty temper).	Powerful, keen, active.
Taurus	Determined (dogged); conservative, practical (materialistic); contented (slow, lethargic); resourceful, opinionated.	Endurance (obstinacy); meditation, enjoyment, musical appreciation.	Deep, sensuous, intuitive.	Deep-rooted, persistent.

Gemini	Quick, versatile (opportunist); alert, shrewd (crafty); restless (irresolute); novelty-seeking, unobtrusive, talkative.	Observation, imitation, self-expression.	Superficial, diffuse.	Fitful.
Cancer	Sympathetic, sociable, domesticated, shrewd, passive (indolent); sensitive (timid, apprehensive, moody).	Cherishing, reliving experience, romantic idealization.	Strong, greatly influenced by environment, 'mother complex'.	Well-developed, active.
Leo	Generous, dignified (conceited); loyal, luxury-loving (self-indulgent); vital, confident (opinionated).	Leadership (refuse to recognize limitations); receiving admiration, enjoyment, radiating warmth.	Passionate – when heart is implicated.	Fertile.

The Moon—*continued*

	Personality	Capacity for	Feelings	Instinct, Imagination
Virgo	Industrious, reserved, unassuming (timid); fastidious (fault-finding); studious, cold (aloof); practical (calculating).	Service, dealing with detail.	Minutely analytical.	Limited.
Libra	Peace-loving (lazy, evasive); eager to please (too dependent, approbative); charming, friendly, hospitable, tolerant.	Comparison, co-operation.	Refined.	Sensitive.
Scorpio	Magnetic, determined (fanatical); sensitive (brooding); proud, self-reliant (hard-bitten); controlled.	Self-defence (retaliation); regeneration (self-torment); reliving experiences, investigation.	Intense, passionate, lasting.	Acute

Sagittarius Outspoken (argumentative); honourable, roving (restless); highly independent (cannot endure restriction); fitfully enthusiastic (superficial, diffusive); buoyant.	Exploration, inquiry, movement, disseminating knowledge.	Warm, spontaneous, intuitive.	Easily stimulated.
Capricorn Steadfast, reliable, fatherly, serious (gloomy, brooding); self-demanding (exacting); ambitious (time-serving); prudent (cautious, suspicious); austere (unsympathetic); capricious; (repressed by mother).	Diligent application.	Self-centred.	Sluggish.

The Moon—*continued*

	Personality	Capacity for	Feelings	Instinct, Imagination
Aquarius	Humane, sincere, logical, independent (reserved, quietly obstinate); unconventional (eccentric, inefficient); progressive, ingenious (erratic); friendly.	Altruism, character reading, spreading ideas.	Detached (indifferent, fretful.)	Well-developed.
Pisces	Sentimental, imaginative (dreaming, unpractical, deceptive); susceptible (indecisive, weak-willed); passive (lazy); gentle, kindly, inconstant (restless); retiring, cheerful (easily discouraged).	Self-indulgence, sociability.	Deep, ever-active.	Powerful.

MERCURY

	Mentality	Method of Expression	Adaptability	Perceptions	Lacks
Aries	Alert, clever, first thoughts best.	Direct (disconnected); forceful, spirited (argumentative); uncontrolled (exaggerated); repartee (irony).	Spontaneous.	Quick, acute, inspired.	Concentration, continuity, patience, repose, restraint.
Taurus	Practical (tentative); deliberative (sluggish); well-drilled, constructive, determined, opinionated (stubborn, biased).	Conventional, dogmatic, reiterative, slow, considered, diplomatic.	Strictly limited (nonexistent).	Slow, intuitive, indelibly registered.	Inspiration, flexibility, versatility.

Mercury—continued

	Mentality	Method of Expression	Adaptability	Perceptions	Lacks
Gemini	Ever-active (easily diverted, slapdash); versatile, inventive (tricky); logical, inquisitive, studious, dispassionate, categorical.	Witty (slick); voluble, humorous, rational.	Instinctive, continuous.	Rapid (superficial); many-sided, easily stimulated.	Persistence, passion, instinct.
Cancer	Clear, receptive, assimilative, circumscribed, emotionally swayed, reflecting (dreamy); retentive.	Colourful (loquacious); imaginative.	Fitful.	Clear, instinctive, emotionalized.	Originality.
Leo	Creative, self-sufficient (self-satisfied); comprehensive, broad.	Authoritative (dogmatic); dignified	Small.	Broad (hazy).	Humility, sense of detail.

	(overbearing); spectacular (blunt); sequential.			
Virgo Logical, scientific, practical, critical (hypercritical); well-drilled, diligent, mathematical, subtle, easily educated.	Systematic, lucid, correct (pedantic); businesslike; detailed, eloquent.	Well-regulated.	Speedy, accurate, discriminative, narrowly focused.	Breadth, confidence.
Libra Well-balanced (unbalanced); rational, comparative (shallow); judicial.	Precision-seeking, persuasive, (over-diplomatic, flattering); polished.	Superficial, studied.	Well-ordered, easily distracted, intuitive flashes.	Expediency, decisiveness, application.
Scorpio Probing (ruthless); shrewd, critical (sceptical); secretive, highly prejudiced, resourceful.	Trenchant (bitter); positive (intolerant); diplomatic.	Limited.	Acute, penetrating.	Detachment, variety.

Mercury—*continued*

Mentality	Method of Expression	Adaptability	Perceptions	Lacks
Sagittarius Independent, versatile, roving, casuistic, aspiring (opportunist).	Direct (slangy); impulsive (garrulous, unco-ordinated); argumentative (caustic); propaganding	Temporary.	Superficial, transitory, inspired.	Reflection, continuity, judgement.
Capricorn Clear (unimaginative); methodical (rigid); profound, resourceful, cautious, (narrow, suspicious); persevering.	Dry, diplomatic (sardonic); conventional (stilted); well-timed, carefully cultivated.	Capricious.	Slow, limited.	Optimism, flexibility, lightness of touch.
Aquarius Original, clever, abstract (superficial); comprehensive (vague); scientific, detached (cold); synthetic.	Dialectical, accurate (prosy); agreeable, witty.	Unpredictable.	Penetrating, well-drilled.	Warmth, imagination.

Pisces

	Affections	*Love of*	*Seeks Harmony through*	*Disposition*	
Pisces	Receptive (listless); reflective (superficial); illogical (ruled by feelings, confused, hazy); greatly prejudiced (unstable).	Subtle (involved); diplomatic, unguarded (indefinite); humorous, voluble.	Chameleon-like.	Logic, detachment, stability.	Ultra-sensitive, photographic.

VENUS

	Affections	*Love of*	*Seeks Harmony through*	*Disposition*
Aries	Impetuous (inconstant); unrestrained, demonstrative, easily aroused (short-lived).	Romantic adventure.	Mental activity, devotion to ideals, concentration on essentials.	Straightforward, unadaptable, enthusiastic.

Venus—*continued*

	Affections	Love of	Seeks Harmony through	Disposition
Taurus	Strong, steadfast, physical, slow to unfold.	Nature, food, possessions.	Art, music, obedience, contact with materials.	Sociable, generous, conservative, domesticated, placid.
		Often gives physical beauty, magnetism, charm.		
Gemini	Dispassionate (flirtatious); spontaneous (superficial);	Intellectual pursuits.	Relationships, travel.	Good humoured, refined, communicative, youthful, sympathetic.
Cancer	Devoted (clinging); motherly (over-sentimental); susceptible (partisan).	Domestic life, food, romantic ideas.	Family, home, imagination (self-insulation).	Gentle, ingratiating, acquisitive.

Leo	Whole-hearted, faithful, inspiring response, heart rules head.	Pleasure, luxury, display, adulation.	Creative activity, dramatic self-expression – especially arts, warmth of approach.	Generous (indiscriminate); noble.
Virgo	Pure (fastidious); controlled (aloof); discriminating (exacting).	Moral beauty.	Service, celibacy, self-abnegation, routine, avoidance of intimate relationships.	Detached (callous); (fear of self-surrender).
Libra	Tender (too refined); susceptible (dependent); easily expressed (over-sentimental, flirtatious).	Harmony, simplicity, colour, proportion, etiquette.	Aesthetic pursuits, partnership, graceful self-expression, idealization of romance, pleasing others.	Sociable, charming, dignified.
Scorpio	Passionate (insatiable); possessive (jealous, unscrupulous).	Sensation (lascivious, dissipated); luxury, flattery, secrecy.	Purification of desires (self-indulgence); revaluation of experience.	Highly sensitive, proud, extravagant, tactless.

Venus—continued

	Affections	Love of	Seeks Harmony through	Disposition
Sagittarius	Impulsive, (superficial); sincere (fickle); unsubtle (easily rebuffed); adventurous (precocious, flirtatious).	Philosophy, open air pursuits.	Freedom, travel, exploration (evasive actions); multiple relationships).	High-spirited, proud.
Capricorn	Constant, sincere (limited); lasting, protective, shy (difficult to awaken, slow developing, dreads rebuff); prosaic (coarse); challenging.	Excellence, pleasure (sensuality); domestic life.	Developing self-reliance, eliminating unwanted restrictions.	Worldly, self-seeking, melancholy.
Aquarius	Idealistic, impersonal (scattered, aloof); unselfish, controlled (unenterprising); suddenly aroused, experimental.	Social life, intellectual companionship.	Search for reality, intellectual development, music, poetry, painting.	Humanitarian, unconventional, friendly.

	Desires	Stimulates	Energy	Method	Attitude	Lacks
Pisces	Tender, devoted, easily swayed (indiscriminate); yielding (abject).			Beauty, music, poetry, romantic dreams.	Sharing emotions, exercising compassion, self-sacrifice.	Peaceful, lazy, (inert).

MARS

	Desires	Stimulates	Energy	Method	Attitude	Lacks
Aries	Strong (uncontrolled); ardent (inflammable).	Independence, enterprise, combativeness, mechanical ability.	Primitive, abundant.	Direct (impetuous); spontaneous.	Positive, forceful, (aggressive); dauntless (reckless).	Patience, sympathetic understanding; self-control.
Taurus	Earthy (luxurious).	Craftsmanship.	Controlled, calm, applied.	Persistent, persevering, practical.	Determined, (headstrong, vindictive); stoical, (stolid); faithful, worldly (self-indulgent, conceited).	Thrust, mobility.

Mars—continued

	Desires	Stimulates	Energy	Method	Attitude	Lacks
Gemini	Spontaneous, evanescent.	Communicativeness, sense responses.	Nervous, intermittent (quickly dissipated).	Alternating, adjusting, inspirational flashes.	Observant, alert (excitable); plainspoken (destructive, argumentative, sceptical); restless (indecisive, frivolous).	Developed intellect, continuity.
Cancer	Strong (sensuous).	Instincts, feelings, imagination, self-preservation, acquisitiveness, memory, tenacity, domesticity.	Emotional, cohesive.	Subtle, indirect, gradual encroachment, persistent attrition, inconstant, defensive.	Moody (peevish, resentful); cautious (apprehensive); protective, sympathetic (self-indulgent).	Direction, abandon.

Leo

Impulsive, passionate (unbridled); ardent (inflammatory).	Leadership, enthusiasm, benevolence.	Totally mobilized, exuberant.	Dramatic (ostentatious); comprehensive.	Authoritative (militant); hearty (brash); fearless, independent, chivalrous (easy-going); hot-tempered, candid (rude); loyal.	Humility, grasp of detail, disciplined energy and passion.

Virgo

Sublimated (unawakened).	Technical and executive skill, ability to serve.	Disciplined.	Efficient, selective, practical, analytical, logical, scientific, strategic (surreptitious).	Diplomatic (scheming); calculating, discriminating, clinical, cold (unresponsive); critical (dissatisfied, argumentative, officious); unassuming.	Imagination enthusiasm, physical courage,

Mars—*continued*

Desires	Stimulates	Energy	Method	Attitude	Lacks
Libra Refined.	Power of reaction, compromise.	Relaxed, well regulated.	Adroit, co-operative.	Courteous, amiable (lazy, antipathetic); persuasive (intolerant); conciliatory (ingratiating, temporizing); easily influenced (wavering, approbative).	Sturdy independence.
Scorpio Powerful (insatiable); passionate (sensual).	Perceptiveness, mechanical and executive ability, dedication.	Unflagging, rigidly disciplined.	Thorough-going (ruthless); probing, dissecting, persistent, shrewd (cunning, insidious).	Determined, self-reliant, indomitable (superior); authoritative (domineering); spartan (callous); blunt (caustic); self-contained (unsociable).	Power to to relax.

Sagittarius Impulsive.	Optimism, enthusiasm, aspiration, opportunism, argumentativeness, outdoor activities.	Spontaneously mobilized, fitful.	Speculative, exploratory, swift (slapdash); inspired (unconsidered); discontinuous, superficial.	Frank, sporting, independent (defiant); self-righteous (supercilious).	Endurance, stability.
Capricorn Passionate (earthy); persistent.	Ambition, organizing ability, responsibility.	Efficiently controlled, sustained.	Practical, well-rehearsed, orthodox (unimaginative); vigorous, prudent.	Conscientious, dour (irritable); self-reliant (attempts too much).	Humour, humility, spontaneity, consideration, warmth.
Aquarius Unusual (dispassionate).	Originality, independence, humanitarianism, theoretical understanding.	Dynamic.	Scientific, experimental, (revolutionary); impersonal, abrupt, totalitarian.	Detached (inflexible); friendly, blunt (nervy); (unruly).	Personal touch, feeling.

Mars—continued

Desires	Stimulates	Energy	Method	Attitude	Lacks
Pisces					
Sensual (intemperate).	Receptivity, imagination, charitability.	Unstable, diffused (easily exhausted).	Intuitive (unco-ordinated, indiscriminate); involved, (devious, obscure); infiltrating (surreptitious); reconciliatory, *laissez-faire*.	Pliant, relaxed (indolent); unassuming (shy); humorous, diplomatic (dishonest); dreamy (discontented); self-sacrificing.	Push, self-reliance, aim.

JUPITER

Enthusiasm for	Expands	Mind
Aries		
Active occupations, ideas.	Desire for freedom (rebellious); confidence, mental activities, vital force (rash, impetuous).	Ardent, active (roving); generous (sceptical, materialistic).

Taurus		
Material pleasures (extravagant, acquisitive, indolent, self-indulgent).	Constructive force, devotion, placidity, possessiveness.	Conventional (uninspired, over-conservative); contemplative (slow); sympathetic, charitable, firm.
Gemini		
Self-education, change, novelty.	Pressure of ideas (too versatile); linguistic ability, restlessness (improvident, lacks perseverance); power of expression (verbose).	Clever, scientific, witty, fertile, busy (flighty).
Cancer		
Domesticity, food.	Sympathies, business acumen, acquisitiveness (over-cautious); emotions (mother-complex).	Practical yet imaginative (fanciful); (changeable).
Leo		
High patronage (snobbish); display (ostentatious); righteous causes, good living.	Vitality, affections, magnanimity, extravagance, dramatic sense (theatrical); dignity (vain); faith, desire to lead (autocratic).	Noble, generous, compassionate, comprehensive (vague); jovial.

Jupiter—*continued*

	Enthusiasm for	*Expands*	*Mind*
Virgo	Research, service, categorizing (over-attention to detail).	Discrimination, technical skill (careless).	Practical (materialistic); commonplace, scientific (sceptical); pedagogic, clear, analytical, prudent (cautious, advantage-seeking).
Libra	Partnership (over-anxious to please).	Artistic and harmonious impulses (self-indulgent).	Philosophical, humane, well-balanced (easily swayed); just, impartial, sincere, sympathetic.
Scorpio	Investigation of scientific and natural laws, engineering, chemistry.	Magnetism, will-power (pride); devotion (covetous); passions (self-indulgent, sensual); reserve (self-absorbed).	Resourceful, subtle (intriguing); deductive (suspicious); constructive.

Sagittarius
Speculation (carefree); sport, social contacts.

Philanthropy, love of freedom (perverse, self-justifying); prophetic inspiration; faith (credulous).

Loyal, generous (extravagant, shows off); liberal, tolerant, inquiring (sceptical).

Capricorn
Duty (hypocritical).

Conscientiousness (self-righteous); ambition (autocratic, peevish); thriftiness (stingy); self-control, organizing ability.

Serious (austere); concentrative (opinionated); capable, steadfast, practical (materialistic, over-orthodox).

Aquarius
Humanitarian causes, reform, mental pursuits.

Originality, intuition, sociability, pressure of ideas, imagination, philosophical interests.

Just, humane, tolerant (lazy); theoretical (doctrinaire); open (erratic, undecided).

Pisces
Public welfare, healing.

Devotion (over-emotional); imagination, aesthetic susceptibilities.

Charitable, sympathetic, receptive, impressionable (vacillating); easy-going (self-indulgent).

SATURN

	Strives to develop	Need to cultivate	Character	Lacks	Motivated by fear of
Aries	Self-reliance, sense of duty, will.	Self-sacrifice, caution.	Indomitable (assertive at wrong time, overstrains); retiring, difficult to please (grudging, jealous).	Depth, sense of timing.	Frustration.
Taurus	Determination, prudence, patience, frugality.	Obedience, stability.	Purposeful (stubborn); deliberate, material-istic (sordid, avaricious); solid (lethargic, sullen); trustworthy.	Spontaneity.	Economic dependence, lack of resources.
Gemini	Serious orderly thinking, adaptability, versatility.	Reasoning faculties.	Calculating (cynical); impulsive, obser-vant, accurate.	Application, speed of thought.	Being tied down.

Cancer Emotional expression, domestic interests.	Sympathy, tolerance, altruism.	Tenacious, self-absorbed, timid, pessimistic, opinionated, protective, acquisitive, interested in public welfare.	Buoyancy.	Emotional vulnerability.
Leo Will, faith, sense of honour, organizing ability.	Warmth, magnanimity, humility.	Jealous, haughty autocratic (megalomaniacal); hypocritical.	Humour.	Mediocrity.
Virgo Discrimination, common sense, technical ability, scientific and analytical power.	Self-confidence, originality.	Upright (rigid); industrious, critical (suspicious); (narrow-minded); bashful, worrying.	Faith.	Unknown.
Libra Balance, impartiality, judgement, manoeuvrability.	Harmony, diplomacy.	Honourable, (punctilious); intolerant, insincere, opinionated, argumentative.	Objective experience.	Passionate involvement.

Saturn—*continued*

	Strives to develop	*Need to cultivate*	*Character*	*Lacks*	*Motivated by fear of*
Scorpio	Emotional control, independence, power of investigation, penetration, self-discipline, executive ability.	Nobility of aim.	Egotistical (wanton); acquisitive, relentless, exacting, cold (callous); narrow-minded (hidebound).	Flexibility, forgiving spirit.	Emotional dependence.
Sagittarius	Inspiration, philosophical interests.	Hope, charity.	Independent, cynical, ostentatious, irritable.	Restraint.	Restriction.
Capricorn	Self-control, organizing ability, integrity, economy of effort.	Perseverance, will to serve.	Ambitious (calculating, self-centred); materialistic (suspicious);	Confidence, originality.	Going unrewarded.

Aquarius Humanitarian ideals, detachment, deliberation, understanding of first principles, originality, independence.	Loyalty, altruism.	Reserved, mentally obstinate (imposes own opinions); indifferent to success (unworldly); subtle, considerate (callous).	ponderous, limited, pessimistic, over-cautious, arrogant, mean, bound by habit.	Initiative, gratitude.	Self-involvement.
Pisces Intuition, acceptance, plasticity, passivity, sympathy, imagination, mediumship.	Compassion, renunciation.	Moody (misanthropic); sensitive (morbid); indecisive (fickle, treacherous); dependent (inert); self-sacrificing (weak);		Hope, courage, self-reliance.	Isolation.

URANUS

	Awakens	Destroys	Will	Additional Characteristics
Aries	Independence (rebellious); daring, will to lead, inventiveness, impetuosity.	Caution.	Indomitable (intolerant, unscrupulous, iconoclastic).	Spasmodic enthusiasm, sense of infallibility, brusque, suddenly changes direction.
Taurus	Determination, resourcefulness, constructive energies, love of ease.	Vacillation.	Obstinate (immovable, unyielding).	Passionate (revengeful).
Gemini	Mental energies (possibly genius); associative impulses, ingenuity, inquisitiveness, spontaneity.	Inertia.	Spontaneously persuasive (wavering).	Eccentric (impractical); irritable, nervy, unsympathetic.
Cancer	Imagination, (strange fantasies); instincts, cherishing propensities, domestic impulses.	Insensitivity.	Instinctive (susceptible).	Patriotic, changeable (unreliable); interest in antiques.

Leo Pride, passion, desire to rule (over-assertive, tyrannical); love of pleasure, dramatic sense, organizing ability.	Indifference, aloofness.	Commanding.	Participates totally (hates restraint, revolutionary).
Virgo Discrimination, subtlety, scientific interests, analytical powers, desire for purification, perfection.	Impulsiveness, autocratic outlook.	Unstable (vacillating).	Dogmatic (contrary); sharp (cynical).
Libra Harmonious impulses, aesthetic appreciation, co-operativeness, spirit of compromise, talent for manoeuvre, power of judgement, self-adjustment.	Rigidity.	Delicately balanced (fitful).	Fickle.
Scorpio Power to concentrate, penetrate, investigate; intensity of feeling (sensual);	Reluctance to suffer.	Tenacious (ruthless).	Scientific, mechanical or metaphysical interests, gains understanding

Uranus—continued

	Awakens	Destroys	Will	Additional Characteristics
Scorpio—continued	desire for regeneration (destructive).			through suffering, ceaseless self-examination.
Sagittarius	Desire for enlightenment, spiritual aspirations, prophetic insight (hallucinations); experimental tendencies, courage to rebel (reckless, cruel).	Conventionality.	Spirited.	Excitable, (neurotic); utopian (imposes ideas).
Capricorn	Ambition (pushing); shrewdness, sense of mission (conceited); power of self-discipline (austere); perseverance.	Irresponsibility.	Powerful (unfeeling).	Radical, acquisitive, economical, organizing ability.
Aquarius	Originality, comprehension, progressive thinking (doctrinaire);	Sentimentality.	Wayward.	Self-willed (perverse).

Responsive to	Power to	Inflates or Perverts	Additional Characteristics
scientific, metaphysical interests; humanitarian impulses, urge to emancipate, detachment.			
Pisces Compassion, imagination (fanciful, vague fears); humility, spirit of self-sacrifice, voluptuous desires, aesthetic susceptibilities, devotional and religious impulses.	Materialism.	Unco-ordinated.	Uncertain, unsettled (inconstant); sociable.

NEPTUNE

Responsive to	Power to	Inflates or Perverts	Additional Characteristics
Aries Direct inspiration (aversions, forebodings, perverted ideas); radical ideas (subversive, sceptical, revolutionary).	Propagate ideas.	Self-awareness (craves notoriety); sense of mission (fanatical).	Inhibits placidity.

Neptune—continued

	Responsive to	Power to	Inflates or Perverts	Additional Characteristics
Taurus	Artistic inspiration, physical impacts, (sensuous); natural beauty, music.	Heal.	Business acumen, desire nature.	—
Gemini	Mental stimuli, poetic inspiration, argument (misled by others); casual impacts.	Persuade (over-subtle, cunning).	Quickness of perception (inability to concentrate); desire for variety (restless).	Tortuous mind (crafty, worrying).
Cancer	Emotional stimuli (over-emotional); intuitions, psychic atmosphere (over-impressionable, too negative); home and maternal influence.	Cherish, act instinctively.	Social awareness, susceptibilities, self-indulgence.	May inhibit will.
Leo	Passional stimuli (sensual); romantic impulses (over-	Lead, inspire.	Love of pleasure, flattery;	Passionately certain.

impulsive – warm-hearted); creative inspiration.		egotism, desire for power.	(exaggerating)
Virgo Practical intellectual stimuli; scientific thought; ideals of service, hygiene, social conditions.	Absorb and teach techniques, utilize.	Desire for precision, celibacy; critical acumen (fault-finding).	May inhibit spiritual vision; scheming, cunning.
Libra Aesthetic stimuli, ideals of altruism, humanitarian impulses (unpractical).	Create harmony.	Desire for justice, partnership; compassion (easily moved, cannot hide feelings); desire to compromise (insincere).	May inhibit will.
Scorpio Occult and subtle stimuli.	Investigate, transmute.	Craving for sensation (sensual); secretive tendencies, emotional intensity – magnetic (intemperate, perverse).	May inhibit impartiality.

Neptune—continued

Responsive to	Power to	Inflates or Perverts	Additional Characteristics
Sagittarius Philosophical ideals, prophetic inspiration.	Visualize (forebodings).	Love of liberty – broad sympathies; (utopian ideas, restless) optimism.	May inhibit enterprise.
Capricorn Parental influence, professional environment traditional and conventional influences.	Contemplate, perfect, sacrifice.	Ambition, materialism (selfishness); conscience, business acumen.	May inhibit idealism, mystic sense.
Aquarius Social, political and philosophical stimuli, humanitarian ideals.	Theorize (doctrinaire).	Love of independence.	—
Pisces Mystical ideas (gullible); mass emotions, call of suffering humanity.	Understand, aid and transmute suffering.	Mediumistic tendencies, passivity (lazy, dissolute); aesthetic susceptibilities, desire to expand consciousness (drugs, alcohol).	May inhibit assertiveness, and dynamic action.

PLUTO

	Stimulates	Obsession	Compelling need to achieve
Aries	Individuality, impulsiveness, daring (reckless); desire to reform (revolutionary, rebellious); vigour (violent, revengeful); will-power, resourcefulness, flow of thoughts, ability to revivify.	Might.	Emancipation.
	Exhaust themselves completely.		
Taurus	Utilitarian outlook, endurance (stubborn, defiant, uncompromisingly dogmatic); pensiveness (brooding); artistic genius (sensuality); ability to 'merge' (grasping).	Wealth.	Permanence.
Gemini	Sensation-seeking, inventiveness, search for novelty (frittering away of energy); impetuosity (restless);	Mobility.	Comprehension. (too clever).

Pluto—continued

	Stimulates	Obsession	Compelling need to achieve
	duality, equanimity (bluffing, inscrutable, incomprehensible); ability for repartee (sarcastic, critical); response to immediate contacts – playful, power of synthesis, communicativeness.		
Cancer	Instinct, subconscious mind, egotism, tenacity, psychic tendencies (morbid fantasies); ability to cherish, social awareness (feels personal responsibility for world).	Security.	Emotional maturity.
Leo	Self-confidence, faith in own ideas, pride, passions, desire to rule, managing ability, dramatic instinct.	Megalomania.	Fully creative self-expression.
Virgo	Industry, analytical skill, scientific and technical interests, urge to discriminate and refine (hyper-critical).	Puritanism.	Perfection.

Libra Adaptability, opportunism, love of beauty, justice, social instincts.	Impartiality.	Harmony.
Scorpio Self-will (autocratic); sensitivity to undercurrents, emotional intensity, power of resistance (intractable, indomitable); fortitude, resourcefulness, penetrative power, investigating ability, destructive tendencies (ruthless).	Inviolability.	Regereration.
Sagittarius Faith in human nature, impulsiveness, enthusiasm (prodigal self-expenditure); sagacity, sense of perspective, prophetic ability, exploration, versatility, joviality.	Freedom.	Right orientation.
Capricorn Ambition, persistence, perseverance, endurance, efficiency, organizing and executive ability, conservatism, materialism.	Recognition.	Self-discipline.

Pluto—*continued*

	Stimulates	*Obsession*	*Compelling need to achieve*
Aquarius	Awareness of Truth, powers of synthesis, altruism, humanitarianism, psychological understanding, intellectual interests, originality, ingenuity, unconventionality.	Detachment	Free self-expression.
Pisces	Compassion, impressionability, imagination (morbid); susceptibility (sentimental); sense of universality, self-sacrifice, plasticity, resignation, power to relax.	Renunciation.	Understanding.

The Houses of the Horoscope

THE Earth's changing relationship with the Sun, Moon and planets as it travels each year in its more or less circular orbit round the Sun is charted against the background of the twelve zodiacal signs. The changing relationship of any given place on earth with the Sun, Moon and planets as the Earth rotates each day on its axis is charted against the background of the twelve houses of the horoscope. Both the signs of the Zodiac and the houses of the horoscope, therefore, depend for their basis upon different aspects of the Sun-Earth relationship.

Overleaf is a blank horoscope wheel. (Figure 1).

A completed horoscope is a map of the heavens (or more correctly of the Solar System) as it is at one particular moment of time, drawn according to certain conventions. The small circle in the middle represents the Earth and the horizontal lines on the East and West represent the horizon extended on either side to meet the circle of the heavens (the inner of the two outer circles). The Sun rises on the Eastern horizon and sets on the Western; so the sunrise point is called the Ascendant and the sunset point the Descendant. The semi-circle above the Ascendant-Descendant axis represents the arc of the heavens that is visible to us, the hemisphere below the horizon that part of the heavens hidden from our view. The vertical axis of the horoscope, from South to North, cuts the circle of the heavens above the earth at the place where the Sun is at midday, and below the earth at the place where the Sun is at midnight. This axis is a projection into space of a great circle round the earth joining the North and South Poles. These great circles, which cut the Equator at right angles, are called Meridians (from a Latin word meaning 'middle of the day') as they indicate the direction of the Sun at noon for all those places that lie along the circle. The Upper Meridian is also known as the Midheaven or Medium Coeli (M.C., 'middle of the heavens'), the Lower Meridian as the Imum Coeli (I.C., 'lowest part of the heavens').

The quadrants formed by the upper and lower meridians and the horizon are each trisected according to special and rather complicated formulae, which divide either the ecliptic or the equator into twelve equal parts. Because of the spherical nature of the earth's surface, the

farther away from the equator we move, the more uneven do these divisions become, so that in extreme North and South latitudes the pairs of quadrants differ greatly in size, producing six very squeezed up and six very elongated houses. Even in moderately high latitudes

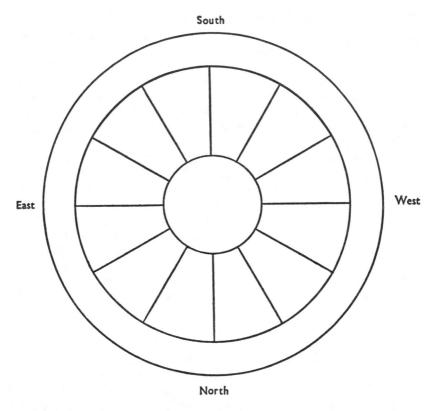

South

East

West

North

FIG. 1

there is a pronounced inequality in size and if you look closely at the Tables of Houses you will see that in Northern latitudes the first house contains a large area of the zodiac when ♒, ♓, ♈ and ♉ are rising and a correspondingly small area when the opposite signs ♌, ♍, ♎ and ♏ rise. In other words, the signs ♒, ♓, ♈ and ♉ (called signs of Short Ascension) pass quickly over the horizon so that in the natural order of things fewer births take place when these signs are

on the Ascendant, most when ♌, ♍, ♎ and ♏ (signs of Long Ascension) are rising. In Southern latitudes the position is exactly reversed – signs of Long Ascension are those that were signs of Short Ascension north of the equator. At the Poles, the position is further complicated by the fact that for six months at a time the Sun is continuously above the horizon and therefore does not rise or set.

A good deal of controversy exists amongst astrologers as to the correct way of trisecting the quadrants (mainly as a result of trying to reconcile the fact that the plane of the ecliptic does not coincide with the plane of the equator). Some indeed have abandoned such attempts and adopted equal house systems, measuring off either from the Midheaven or the Ascendant successive 30° areas to represent the houses. The writer recommends the system of house division invented by Placidus, which trisects the quadrants on a time and not on a space basis and for which Tables are available giving the cusps of houses for most of the latitudes that the student is likely to require. A cusp is the point in a house where the planet reaches its maximum power in relation to the things signified by that house. Strictly speaking it is not a fixed boundary between one house and the next although a planet more than 5° earlier in the zodiac than the cuspal degree can be regarded as having left the sphere of influence whose maximum emphasis is marked by that cusp.

The meanings of the houses are derived in much the same way as the meanings of the zodiacal signs, for the daily cycle is somewhat akin to the yearly cycle in its significance. Sunrise is equivalent to Springtime, when the whole world of nature begins to stir once more and becomes aware of itself. The Eastern half of the horoscope is therefore connected with consciousness of self and the opposite Western hemisphere, containing the quadrants preceding and following sunset, represents the consciousness centred in things outside the self, the not-self. The noonday Sun is equivalent to high Summer and represents the peak of achievement. The hemisphere of which the Sun at noon is the apex represents objective consciousness – the light of the Sun is cast over the whole hemisphere for all to see. The hidden, or night hemisphere through which the Sun passes from sunset to sunrise, represents the subjective consciousness, the realm of intuition and feeling, and the midnight position of the Sun represents the heart of Winter, when all the vitality of nature is indrawn, awaiting the opportunity to become manifest again in the Spring (or at dawn in the daily cycle). The Ascendant-Descendant axis therefore cuts off the hemisphere representing subjective consciousness

from the upper hemisphere representing objective consciousness; just as the M.C.–I.C. axis cuts off the Eastern hemisphere representing consciousness of the self from the Western hemisphere representing consciousness of the not-self. This is the reason for the great importance attached to these axes of the horoscope.

Combining the significance of the two intersecting sets of hemispheres we can arrive at the following meanings for the four quadrants: From Ascendant to I.C., Subjective Self-Awareness, Intuition; from I.C. to Descendant, Subjective Awareness of the Outside World, Emotion; from Descendant to M.C., Objective Awareness of the Outside World, Sensation; from M.C. to Ascendant, Objective Self-Awareness, Thinking.

The division of each quadrant into three sectors reminds us of the three different modes (cardinal, fixed and mutable) in which the signs express themselves. The houses are numbered in an anti-clockwise direction, beginning with the sector immediately below the Ascendant. Angular houses (the first, fourth, seventh and tenth) like cardinal signs are related to an initiatory phase of activity. Succedent houses (the second, fifth, eighth and eleventh) like fixed signs are related to a consolidating phase of activity. Cadent houses (the third, sixth, ninth and twelfth) like mutable signs are related to an alternating phase of activity, linking the activities of the two previous houses and preparing the way for the next.

Houses 1, 2 and 3 together make up the quadrant of intuition. The first house represents the natural easy instinctive self-expression that is most characteristic of the native. This also includes his physical appearance and mannerisms. It shows his outward attitude and the way he presents himself. The second house shows how he is able to establish himself on all levels through his resources – spiritual, mental, emotional as well as physical. It shows his earning power and his ability to gather possessions. The third house shows how, once established, he relates himself to his immediate environment, his attitude to everything near at hand, to neighbours, relatives. It shows the means of effecting such relationships, through travel, education and everything that aids communication. It relates also to the development of the mental powers.

The quadrant beginning with the fourth house is that related to the feelings. Having come to terms with his immediate environment, the native seeks to identify himself with one chosen part of it and in a more specialized way. The fourth house therefore represents the native's home, his parents, his heredity, his past tendencies and

everything which gives him a feeling of security. It also represents the early years of his life in which he is preparing to establish himself, and old age when he is assimilating, after retiring from outward activity (above the horizon), the experiences that have gone before. The fifth house represents the native's ability to establish himself on a wider basis by harnessing his emotional capacities in some form of individual creative self-expression, either physically, through begetting offspring, through hobbies or through the pursuit of pleasure in general. It is the house of entertainment, courtship and pets, which may be an emotional substitute for children. The sixth house represents the way in which the native's emotional self-expression is refined and directed into various channels through his ability to adapt himself and master various techniques, including the laws of the world of nature. It is the house of service and craftmanship. Failure to achieve a reasonable standard of adaptation may lead to a lack of progress and consequent frustration and ill health, so that the sixth house has a special connection with illness.

At the seventh cusp we arrive at the quadrant of sensation, where the self, having perfected to a relative degree its talents, is projected into and extended through co-operation with the outside world. The seventh house represents the native's ability to work in harmony with others and that with which he seeks to combine owing to his own sense of lack. It is the house of all kinds of partners, particularly the marriage partner and, if the native fails in his attempt to achieve harmonious relationships, of open enemies. The eighth house represents the native's ability to perpetuate his relationships (which can be a source of real power) and his attitude to other people's resources. It is the house of death (ultimate failure to perpetuate relationships), regeneration (as a result of the impact of others) and loss (failure to capitalize upon partnerships). The ninth house represents the power of the native to deploy the resources acquired as a result of contacts with others. It is the house of wider relationships, increased perceptions (resulting from regeneration), which may bring revelation, the wider vision and inspiration given by religion, philosophy and science, and higher education and prolonged travels which serve to broaden and develop the mind.

With the tenth house there begins the quadrant of thinking and the projection of the self (enlightened by the revelations of the ninth house) upon the community. The tenth house therefore represents the native's attitude towards the community, which determines his status in that community and the function he is likely to fulfil in it.

It is the house of career and the parent who guides the native's aspirations. The eleventh house represents the native's ability to stabilize his position in the world and is related to his hopes and wishes. Friends who assist the native to realize his possibilities in this direction and indirectly help to determine his standing are also ruled by the eleventh house. The twelfth house represents the native's ability to secure the fulfilment of his hopes and wishes on many levels and in many directions. It shows his capacity for complete integration with life. To the degree in which he fails to achieve this, his wishes will remain pipe dreams, weaknesses not overcome will prove to be his undoing and may create frustrations that bring on illness, misfortune or lead him into anti-social behaviour.

As the Earth rotates, each sign will pass successively over the various house cusps. At any given moment of birth the sign found on the cusp of a house indicates the attitude of the native to the affairs governed by that house and the planet ruling the sign is said to be the ruler of that house. Virgo on the cusp of the second house will therefore show that the native is discriminative in his attitude towards possessions. Matters related to health or service may have some connection with his income. Mercury, as the ruler of Virgo, will be the ruler of his second house, and the house in which it is placed will accordingly be linked with the second house. Thus if Mercury were in the fifth house in Sagittarius, children (fifth house) overseas (Sagittarius) might contribute to the family income or be a source of loss according to the aspects to Mercury. A planet placed in the second house will have much influence over the affairs of that house, according to its intrinsic nature.

The planet ruling the sign on the cusp of a house is known as the accidental ruler of that house. The planet ruling the sign corresponding to the number of the house is called the natural ruler of that house. Taurus is the second sign and corresponds to the second house and so Venus is the natural ruler of the second house; similarly with the other houses.

It sometimes happens in the quadrant systems of house division that there are more than 30° between one house cusp and the next. This means that one complete sign (and in extreme cases, more than one sign) are 'intercepted' between the two cusps and the planet ruling a sign thus intercepted is regarded as being the subsidiary accidental ruler of the house. It has less power than the ruler of the sign on the cusp and the affairs denoted by the intercepted sign, and by any planets in that sign, may be slightly more difficult to give open

and free expression to than would have been the case had the sign not been intercepted.

The following interpretations of the effects of the planets in each house of the horoscope are intended as a general guide to delineation. Due allowance should be made for the modifying effects of sign position and aspects received. Unless afflictions are severe and the general condition of the horoscope adverse, the comments in brackets may not apply!

FIRST HOUSE

Sun

Strong-willed, confident, independent, responsible, authoritative (dictatorial, power-seeking); frank, upright, dignified (pompous, egotistical); prominent (hampered); good (poor) vital and recuperative powers.

Moon

Feelings prominent, romantic, imaginative, sensitive to environment (restless, easily influenced); curious, love of travel, change, direct contacts, novel experiences; sociable, timid, thrifty, publicity-seeking; soft constitution; dissipates energies.

Mercury

Adaptable (unreliable); shrewd, inquisitive, youthful, precocious (superficial); active (restless); excitable (nervy); eloquent (talkative, sarcastic); jumps to conclusions, humorous, good mimic.

Venus

Affectionate (flirtatious, too trusting); harmony-seeking (submerged in sensation); pleasant, cheerful, sociable, sympathetic; honest, docile, artistic, fond of appreciation.

Mars

Fiery, independent, impulsive, courageous (foolhardy, heedless of advice); enterprising, pushing (needlessly assertive); tireless, outspoken; strong passions; (fevers, accidents, scar on face).

Jupiter

Buoyant, generous, just, religious (hypocritical, gullible); moral, inspires confidence (untrustworthy, faithless); dignified (pompous); pleasure-loving (self-indulgent); increases vitality.

Saturn
Serious, industrious, reliable, self-controlled (narrow, introspective); reserved (shy, nervous, inferiority complex); cautious (pessimistic, secretive); prudent (suspicious, exacting); persevering, patient, economical (mean); ambitious, shrewd (unscrupulous); ponderous (harsh, stubborn); (malnutrition, colds, bruises).

Uranus
Electric (highly-strung, erratic); strong-willed (wilful); independent (supercilious); original, freedom-loving, unconventional (eccentric); abrupt (blunt); impulsive, restless, lively.

Neptune
Hypersensitive (moody); visionary (absent-minded); idealistic (frustrated, never satisfied); receptive (yielding); imaginative, artistic, sensation-seeking, sensuous, indolent, elusive (tricky, procrastinating); changeable (unstable); whimsical (wasting diseases).

Pluto
Thirst for experience, great potentialities; robust personality, magnetic, adventurous, courageous (obstinate, fanatical, destructive, ruthless); inscrutable (inconsiderate, inaccessible); self-sufficient; sceptical.

SECOND HOUSE

Gain (Loss) through	Money	General Characteristics
Sun		
Father, government, influential people.	Comes and goes easily.	Generous (extravagant); magnanimous, ambitious (greedy, demanding); love of splendour (possessions a status symbol); reserves of strength.

Gain (Loss) through	Money	General Characteristics
Moon Mother, public commodities, liquids.	Rapid turnover, Alternately careless and thrifty (changing fortunes)	Tenacious, shrewd, sensitive to public needs; possessiveness towards nearby objects; over-liberal (wastes substance).
Mercury Brethren, travel, advertising, publishing, journalism, agencies (theft, trickery, bad judgement).	Rapid turnover, fluctuating fortunes.	Financial skill; values things by their immediate usefulness; may collect books.
Venus Marriage, women, art, jewellery.	Assistance from others, expenditure on dress, ornament, finery.	Uses possessions to advantage; expects good income (prodigal); (indolent, greedy).
Mars Machinery, weapons, cattle; (fire); efficiency (haste, rashness).	Earns quickly, spends freely (dissipates resources); frequent crises, swift recovery.	Acquisitive (selfish).
♃ *Jupiter* Travel, food, clothing, gifts, religion; (carelessness).	Confident of prosperity (great extravagance, spends all he gets).	Success through influence; apt to exploit others.

Gain (Loss) through	Money	General Characteristics
Saturn Solid concrete things; real estate; investments, antiques; sheer merit, perseverance, economy; (lack of trust, worthless bargains).	Works hard, (little return) slow gains; (losses bring worry).	Thrifty (parsimonious); shrewd, just; pure motives.
Uranus Unusual sources, electricity, curios, antiques, windfalls; (erratic behaviour, cocksureness).	Sudden spectacular fluctuations.	Independence through resources; ingenious extrication from emergencies.
Neptune Hunches, dreams, speculations; hire purchase, luxury trades, hospitals, films, aviation, shipping, drugs, alcohol, oil, spirits; charity; (fraud, inflation).	Involved finances; (anxieties and disappointments).	Indifferent to money (careless attitude); little financial ability (easily imposed upon); (dishonest).
Pluto Sensational, unusual and adventurous channels; several sources; mining, armed forces, uniformed occupations; (blackmail, crime).	Ability wins high returns (squanderers).	Financial considerations dominate outlook (unscrupulous).

THIRD HOUSE

	Mind	Travel	Relatives Neighbours	General Characteristics
Sun	Broad (confused); impartial, creative, self-reliant (arrogant, domineering); cheerful, lively, accomplished, constructive (disorganized); reformative.	Liking for, success in.	Successful (misunderstandings with).	Success in study; likes to spread knowledge.
Moon	Studious, curious (interfering); common sense, impressionable (easily swayed by environment); imaginative (dreamy, moody, unstable); adaptable (lacks continuity).	Taste for (dislikes); many journeys.	Sympathetic (antipathetic).	Good memory; dislikes routine; opportunist.
Mercury	Alert, busy, studious, versatile (changeable, unstable);	Many journeys.	Superficial contacts; clever (crafty).	Expands mind.

Third House—*continued*

Mind	Travel	Relatives Neighbours	General Characteristics
Mercury – continued inquisitive, witty (crafty); often eloquent, easily educated, affected by environment; copes with details.			Facility of expression.
Venus Artistic, appreciative, pleasant, emotion-swayed (sensuous, pleasure-loving); bright, hopeful, peaceful (superficial); harmonious, tasteful, creative.	Pleasant.	Helpful, agreeable.	
Mars Alert, determined (stubborn, headstrong); independent, energetic, thrustful (sharp); enthusiastic (excitable, not always logical); argumentative (disruptive, carping); executive.	Difficult, arduous; (accidents through hastiness, restlessness, negligence).	(Disputatious annoying).	

Jupiter
Optimistic (self-satisfied); philosophical (unpractical); conventional (limited); earnest, thoughtful, considerate.

Fortunate; likes rapid locomotion; preserved from accident (suffers through carelessness.)

Popular with.

Shares ideas; educational benefits.

♄ *Saturn*
Careful (narrow); exact (slow); conscientious (over-conscientious); serious (melancholy); persevering (laborious); concentrated, reflective (morbid); procrastinating, late in developing.

Unpleasant, delayed (loss through).

Difficult.

Unpunctual.

Uranus
Independent, inventive, ingenious, original, unconventional (eccentric, erratic, bedlam creating); active (inconstant); curious, liberal.

Sudden, unexpected, stimulating; (troublesome; accident during).

Unusual (sudden estrangements, partings).

Suddenly reverses ideas.

Third House—continued

Mind	Travel	Relatives Neighbours	General Characteristics
Neptune Impressionable, intuitive, highly imaginative (obsessions, hallucinations); inspired, idealistic, devotional, artistic, strange (cunning); wandering (unreliable); negative.	Sea and Air (peculiar misadventures).	Uncommon (irreconcilable, afflicted, deceptive).	
Pluto Inspired, versatile, always searching, original, sensational, revolutionary (destructive).	Vital experiences through.	Vitally interested in.	Vital need for self-expression; isolated from other minds; (sabotages relationships he cannot dominate).

FOURTH HOUSE

Inherited Tendencies	Circumstances at End of Life	Parental Influence	Domestic Environment
Sun Stable, conservative (inner doubts, restlessness, world passes unnoticed).	Fortunate.	Strong (early struggle, father has difficulties).	Pride in.

Moon			
Intuitive, self-centred, inner desire for peace and security (restlessness), (insulates self against surrounding reality).	Increased activity, some public recognition (rebuffs).	Maternal influence paramount (separation from parents).	Frequent changes, emotionally attached to (dislikes) home, parents.
Mercury			
Naturally studious, literary interests, young people influence life (suggestible).	Many contacts.	Superficial.	Many changes of residence (finds no peace anywhere); home studies.
Venus			
Fond of own country, entertains well (self-indulgent, jealous of privileges).	Peaceful (sad).	Attached to mother.	Harmonious, fond of home, love of beautiful surroundings (unduly sensitive to environment).
Mars			
Acts consistently (stirs up trouble); (aggressively acquisitive); strong constitution.	Retains independence (involved in disputes).	Early desire for independence (quarrels with parents).	Energetic homemaker (accidents, deaths at home).

Fourth House—*continued*

Inherited Tendencies	*Circumstances at End of Life*	*Parental Influence*	*Domestic Environment*
Jupiter Open and generous (extravagant, ostentatious, conceited).	Comfortable.	Beneficial.	Highly sustaining, successful in birthplace.
Saturn Conserves energy, accumulates (acquisitive, self-seeking, over-anxious; jealous of established prerogatives); (rebels against responsibility); anxious about old age; fated life.	Restricted, lonely.	Limiting (early death of parent).	Early surroundings rarely congenial (uneasy, cramped); rarely changes.
♅ *Uranus* Chequered career.	Unusual (enforced changes).	Stimulating (estranged from parents, break-up of home).	Many and sudden changes, strange experiences (cannot settle, no real domestic feeling).

Neptune

General Characteristics	Children	Love Affairs	Speculation
Challenges established security (naively self-absorbed); likely to travel; (sometimes illegitimate).	Secluded (lives in institution).	Spiritual tie (nebulous).	Beautiful, over-idealized (vaguely unsatisfactory); (exhausting).

Pluto

General Characteristics	Children	Love Affairs	Speculation
Great transformations.	Isolated.	Vital (deeply unsettling).	Restless in birth-place, whole world his home.

FIFTH HOUSE

General Characteristics	*Children*	*Love Affairs*	*Speculation*
Sun Creative ambition (exhibitionist); power to enjoy and give enjoyment (exploits others for pleasure).	Few or none, one may shine, ambitious for offspring.	Successful (spoilt by pride).	Success (loss).
Moon Constant search for pleasure; (desires attention).	Several (unexceptional).	Numerous, ardent (fickle).	Fluctuating.
Mercury Love of change, intellectual pursuits, sees fascinating potentials in everyone.	Clever (troublesome).	Platonic (inconstant).	Rapid gains (source of worry).

Fifth House—*continued*

	General Characteristics	*Children*	*Love Affairs*	*Speculation*
Venus	Enjoys life (self-indulgent); pleasure in creative work, can dramatize self (too fond of applause).	Affectionate.	Precocious, pleasant (disappointing).	Gain through entertainment, art (too happy-go-lucky).
Mars	Sport-loving, loyal companion, enterprising, power of leadership.	Lively (unruly); (severe towards); (involved in accidents).	Ardent (rash).	Gain through initiative (loss through rashness).
Jupiter	Loves sport and pleasure (dislikes work).	Large family brings happiness (careless towards).	Well-regulated (indiscreet).	Successful (rash gambles).
Saturn	Suppresses creative instinct, takes pleasures seriously, difficult to relax.	Limited or none (disappointing, sickly); feels responsibility of parenthood (too severe).	Steady, older companion (cool, frustrated).	Gain through land, property, old-established concerns (severe loss).

Uranus

Creative originality, peculiar pleasures, expresses independence through exaggerated self-dramatization (unrestrained self-expression).

Eccentric, adopted; (wayward); (estranged from); (may deny).

Sudden infatuations (abrupt estrangements).

Sudden, unexpected gains (losses).

Neptune

Pleasure-loving (depraved tastes, tires of pleasure); luxury-loving, artistic, over-expectant (disappointed, unhealthily dependent on external stimulus to creative urges).

Dreamy, delicate (disappointment through) great desire for (afflicted, adopted).

Platonic (illicit, chaotic).

Gain through shipping, aviation, oil (loss through fraud).

Pluto

Impetuous desires (unbridled impulses); vital need for creative outlet; transformation or sublimation of sex impulses (perversion).

May deny (danger to).

Impetuous, passionate (unrestrained).

Radical gains (losses).

SIXTH HOUSE

General Characteristics	Health	Employees, Subordinates
Sun Pride in achievement (likes appreciation, vain, complacent); ambition to serve (unsocial); utilitarian aims.	Good (poor recuperative powers, organic complaints); interest in hygiene.	Helpful, (uncooperative, self-seeking).
Moon Desire to serve; interest in techniques.	Functional complaints (sickness in infancy, stomach trouble).	Concerned over (inconstant).
Mercury Knowledge of techniques.	Interest in hygiene (nervous, respiratory or intestinal trouble).	Clever (restless, tricky).
Venus Likes (dislikes) work, may marry social inferior.	Constitution not strong, receives good nursing (throat, kidney or generative troubles).	Pleasant (indolent).
Mars Industrious, efficient (overworks).	Great vitality (feverish inflammatory diseases, operations, accidents, troubles through excesses, carelessness, indiscretion).	Energetic (quarrelsome).
Jupiter Capacity for loyal service (does too much).	Good (trouble through surfeits, blood, liver, obesity).	Helpful (careless).

Saturn
Unobtrusive, conscientious worker (over-conscientious or shirking).

Poor recuperation (colds, chills, rheumatism, trouble through debility, neglect).

Reliable (unsympathetic, dull).

Uranus
Original methods (erratic workmanship).

(Nervous disorders, strange accidents, incurable complaints); benefits from unorthodox treatments.

Unusual (unreliable, fractious).

Neptune
Altruistic ideals (lacks application, dislikes exertion).

Sensitive to environment (troubles through self-indulgence, contagious diseases, wasting, atrophy, deformity); (avoid drugs).

Devoted (treacherous, lazy).

Pluto
Mobilizes resources, intent on service.

Interest in healing (infectious, deep-seated diseases).

Co-operative, thorough (unscrupulous).

SEVENTH HOUSE

General Characteristics	*Partnerships and Marriage*	*Enemies*
Sun		
Pride in relationships (clashes with others); opportunist.	Beneficial (unsuccessful); ambitious plans; delays marriage for a woman, marriage in middle life, firm, honourable partner.	Powerful.

Seventh House—*continued*

General Characteristics	Partnerships and Marriage	Enemies
Moon Popular (unpopular); responsive to others (over-sensitive).	Several opportunities to marry; early marriage, domesticated (fickle) partner, needs companionship.	Among women.
Mercury Seeks intellectual contacts.	Younger partner, may marry relative (restless, quarrelsome partner).	(Worrying, scandal-mongering).
⚶ *Venus* Affectionate approach to others (draws back prematurely).	Early, happy (disappointing) marriage; attractive, fortunate partner, fruitful union.	Gain through adversaries, pacifies enemies (leaves others to make first approach).
Mars Highly independent (non-conciliatory, forgetful of others' feelings); concedes initiative.	Short-lived partnerships, early marriage (quarrels, death of partner); independent, ardent, courageous (domineering) partner.	(Aggressive).
Jupiter Sociable, good-natured (over-generous).	Beneficial partnerships (misplaced trust in partner); fruitful, prosperous, successful marriage, sometimes second marriage;	Conciliates opponents (bring lawsuits).

Jupiter—*continued*

generous, faithful
(wasteful, untrust-
worthy) partner.

Saturn

Reluctant to co-operate (over-cautious approach); (feels restricted by others).	(Unfortunate partner-ships); marriage delayed, hindered or partner older – possibly widow or widower; faithful (cold, over-ambitious) partner, (partner dies).	(Persistent, unrelenting).

Uranus

Competition stimu-lates originality, erratic in relation-ships (intractable, misunderstood).	Sudden attachments (may delay or prevent marriage); independent, romantic, original (erratic) partner (separation, divorce).	Unexpected (jealous).

Neptune

Relationships based on admiration or pity, self-sacrificing (easily swayed, expects too much of others).	Ideal or platonic union (scandal, bitter dis-appointment); artistic or invalid partner (denies consummation).	(Plotting, treacherous).

Pluto

Vital need to co-operate (combative, must be first).	Elopement, self-sufficient partner (jealousy, separation, death of partner).	Secret, ruthless (constant strife).

EIGHTH HOUSE

General	*Death*	*Money*
Sun		
Awareness of higher forces, intent on self-improvement, recruits others' support.	Honourable; (through constitutional weakness); (premature death of father, husband).	Steady fortunes, legacy possible (unfounded expectations, extravagant partner).
Moon		
Resigned attitude to death, sensitivity.	In public place (public disaster); (early death of mother, wife).	From mother or wife (unsettled fortunes).
Mercury		
Talent for research, analysis; insight (opinionated).	(Through nervous complaint, lung trouble or while travelling).	Inconstant fortunes (worry over).
Venus		
Experiments with feelings (exacting affections, estrangement).	Peaceful end (death through over-indulgence, kidney trouble, diabetes); (death of wife).	Gain by marriage, women, legacy (extravagant partner).
Mars		
Devotion, enthusiasm for research (disparaging).	Quick (from fever or accident, painful).	(Loss by fire, theft, rash partner).
Jupiter		
Hopefully confident, (sceptical).	Natural (through over-indulgence, liver complaint, carelessness).	Through marriage or legacy, gains (extravagant partner).

Saturn

Capacity for self-discipline.	In old age (from a long-standing complaint, accident).	From property, through perseverance (hampered by limited resources, impecunious partner).

Uranus

Interest in metaphysics, regeneration through intensity of experience.	Sudden end (through nervous trouble, accident).	Unexpected gains (losses).

Neptune

Sensitivity.	(Death in hospital); (through drugs, wasting diseases).	Fluctuations (disappointments, thriftless partner).

Pluto

Vital search for meaning of life (anarchical, obsessed).	In public place (unfortunate end).	Greatly concerned over resources.

NINTH HOUSE

Sun

High ideals (fanatical); broad wisdom, love of travel, foreign journeys.

Moon

Receptive imaginative mind (dreamy); sincere beliefs (superstitious); prophetic (superficial); may change opinions; able to teach; voyages.

Mercury

Mental inspiration; flexible adaptable mind (indecisive, worrying, flippant, promises too readily); speedily finds connections (meddlesome); inclines to travel (wanders aimlessly).

Venus

Creative inspiration (longing for unattainable); sympathetic understanding, devotional, intuitive; love of travel, pleasant (unpleasant) journeys; possibly marriage abroad or to a foreigner.

Mars

Independent in thought (exaggerating, self-justifying); propagandist (fanatical); fights for convictions (ill-timed partisanship); (feels unappreciated in own country); love of change (dangerous journeys).

Jupiter

Noble mind, sound moral outlook (conventional, hypocritical, arrogant); interest in religion, philosophy; tolerant; foresight; education through travel (accidents while travelling).

Saturn

Grave enthusiasm, austere outlook (pessimism, agnosticism, bigotry); meditative (critical, too much cogitation); orthodox; difficulties in travel.

Uranus

Seeks to widen horizons; independent, unorthodox philosophy (iconoclastic); prophetic; inventive mind; sudden unexpected journeys (unfortunate travels).

Neptune

Mystical, idealistic outlook (chaotic; religious mania); imaginative, intuitive (dreamy, vacillating, inconclusive); long journeys (complications abroad).

Pluto

Vital interest in philosophy, religion (fanatical); great urge to expand knowledge (muddled, revolutionary mind); keenly intuitive (false impressions); love of travel, adventure (sensation-seeking, danger abroad).

TENTH HOUSE

Sun

Strongly self-conscious, determined to achieve (arrogant, dictator-

ial, ambitious for power); success, high position, patronage (unsympathetic superiors).

Moon
Ambitious (loves prominence); changes in occupation, may travel (unstable position); career benefits through women (subject to scandal); dealings with public.

Mercury
Uses knowledge profitably (unpractical); adaptability aids career (jack-of-all-trades, deceitful); literary or commercial success; travel in occupation, changes in employment.

Venus
Very sociable (self-indulgent); pleasant experiences, artistic career, success, honour (disappointment); help from women (scandal); marries above station.

Mars
Desires conquest (domineering, enmity in career); inexhaustible energy (attempts too much); resolute, independent (quarrelsome); success through enterprise (unrealized ambitions); lives in present; active occupation.

Jupiter
Great desire for achievement, mixes easily; success, honour, esteem, rise in life (unreliability brings reversals); important patronage.

Saturn
Firm, self-reliant, independent, ambitious, desires respect (discontented, over-ambitious); sound, responsible, success through perseverance (discredit, downfall); (fated life).

Uranus
Desires absolute freedom; powerful position, sudden advancement (chequered career, disfavour); unconventional, success through originality, many changes (vicissitudes).

Neptune
High aspirations (dissatisfied, resents criticism); lacks application (swayed by moods, self-doubting, unpractical); artistic occupation; (public scandal).

Pluto
Vital need for power, independence (self-assertive, dictatorial, tyrannical, callous); can mobilize support (loss of power, prestige); unforeseen twists in career.

ELEVENTH HOUSE

Sun
Socially ambitious (ostentatious); co-operates successfully, popular; firm, faithful, influential friends.

Moon
Easy social contacts, popular, many acquaintances, women friends (unreliable friends, scandal); several children.

Mercury
Comprehensive mind (hypercritical); adaptable; intellectual (changeable, insincere, deceitful) friends.

Venus
Fond of company, ideals of brotherhood, affectionate, happiness through friends (scandal); artistic, cultured (jealous) friends, women friends; fruitful marriage.

Mars
Strong desires, powerful wishes (frustration); social leadership, many casual associations (touchy in relationships); masculine friends, energetic, enterprising (dominating, quarrelsome) friends.

Jupiter
Ideals of brotherhood, love of social life, popular, many friends; faithful, influential, beneficial friends (parasitical); fruitful marriage, helpful children.

Saturn
High aspirations (frustration); fatherly attitude (meddlesome); few but lasting friendships; older, faithful, reliable (selfish) friends; (few children, death of child).

Uranus

Original aspirations, advanced ideals (obstinate, wilful); remarkable friendships, sudden attachments, estrangements; unconventional, independent, inventive, occultist (eccentric, wayward) friends.

Neptune

Idealistic (quixotic, uncertain aims); demands too much of friendship; wide circle of artistic, intuitive (deceitful) friends; (very susceptible to friends' influence).

Pluto

Vital need for friendship (peculiar relationships); reformers, idealists; able to influence friends; (no children); (sudden estrangements, death of friends).

TWELFTH HOUSE

Sun

Difficulty in proper self-expression (lacks confidence); senses basic unity of life, aware of life's undercurrents (eccentric); prefers quiet and seclusion (danger of exile).

Moon

Feels neglected (emotionally frustrated); seeks synthesis; emotionally responsive (moody, inconsistent); (illness of wife, enmity of women); (learns through suffering).

Mercury

Contemplative, intuitive, subtle, perceptive (self-absorbed, avoids decisions or thinks opinions infallible); keeps secrets (scheming); (lacking in technique, gift of expression); (misunderstood, slandered, worries over trifles); (one sense defective).

Venus

Emotional sensitivity (sensation-seeking); charitable, unselfish (easily imposed upon); (clandestine romance, marriage difficulties); (sickness through over-indulgence); pleasure through occult study.

Mars

Turns everything to advantage (disruptive); strongly impulsive (needs appreciation, vehement feelings); (danger of slander, treachery); (painful illnesses).

Jupiter

Philanthropic, religious, faith in providence (complacent, counts on being helped); wins over enemies (religious disputes).

Saturn

Reserved, solitary, acquisitive (fearful, doubting, lacks confidence); questions intuitions; work in seclusion (enforced isolation); (persistent enemies); (prolonged illness).

Uranus

Highly intuitive, humanitarian, metaphysical interests (shocks aid progress) (vague fear of disaster); (unforeseen enmities); (loss of reputation, estrangements, exile, restricted independence, accidents, nervous troubles).

Neptune

Contemplative, charitable, sympathetic (morbid fears); (treacherous enemies, difficult illnesses, confinement).

Pluto

Vital need to achieve understanding of life (suppressed emotions, morose, sudden outbursts); led into temptations (subversive activities, betrayal, ambush); (lingering, insidious illnesses).

The Aspects

Two people pulling on a rope usually make their presence felt more effectively than one person pulling alone. Similarly, two planets placed together in the same part of the Zodiac combine to place a greater emphasis on that area. When two or more planets are within a few degrees of each other they are said to be in conjunction. The closer they are together, the more exact the conjunction and the stronger the emphasis. Planets more than 8 or 9° apart are hardly close enough to combine their rays effectively, consequently the 'orb' or maximum distance allowed between two planets if they are to be regarded as being in conjunction is 9°. A third planet standing midway between two others that are beyond the normal orbs of a conjunction, can, if it is itself within orbs of a conjunction of both, unite the two flanking planets by virtue of its mediating position. Three or more planets in a sign are known as a satellitium.

A planet within 3° of the Sun is said to be 'combust' – that is, rendered incapable of operating in its most characteristic manner because it is overpowered by the brilliance of the Solar rays. It may signify a close spiritual identity between the native's innermost self and the planetary quality concerned.

The rays of two or more planets may also combine their influence if they impinge upon the birthplace from different points in the heavens which are a certain number of degrees apart. These distances are known as 'aspects' – the angle at which one planet 'looks at' another. The most powerful aspects are those based on the division of the circle (360°) by 2, 3, 4 and 6, to give arcs of 180°, 120°, 90° and 60°. Planets 180° apart are said to be in opposition; 120° apart in trine; 90° apart in square; 60° apart in sextile. Less powerful minor aspects are based on the half-square of 45° (semisquare) and half-sextile of 30° (semisextile). The complementary angles of 135° (sesquiquadrate) and 150° (quincunx) are also used. There is a special symbol for each aspect, which the student should learn by heart. These are the principal aspects, their nature and the orbs allowable:

Aspect	Distance	Symbol	Orb	Nature
Conjunction	0°	☌	8–9°	Variable
Semisextile	30°	⊻	3–4°	Moderately easy
Semisquare	45°	∠	3–4°	Moderately difficult
Sextile	60°	✱	6°	Easy
Square	90°	□	9°	Difficult
Trine	120°	△	9°	Easy
Sesquiquadrate	135°	⚼	3–4°	Moderately difficult
Quincunx	150°	⊼	3–4°	Moderately difficult
Opposition	180°	☍	9°	Difficult

Aspects based on a division of the circle by five are used by some astrologers. These 72° aspects are called quintiles. Semi-quintiles are 36° and bi-quintiles 144°.

By measuring off four arcs of 90° along the circumference of a circle and joining the points together by straight lines, we can form a square, the symbol of the 90° aspect. By similarly measuring off three arcs of 120° and joining the three points together we can form an equilateral triangle, the symbol of the trine aspect. Aspects based on the square (45°, 90°, 135°) introduce a certain amount of friction into the power generated. Aspects based on the triangle (30°, 60°, 120°) are smoother in operation – hence the former are often labelled inharmonious, the latter, harmonious. Much, however, depends upon the intrinsic nature of the planets in aspect and upon whether they are placed in congenial signs. Especially is this the case with the conjunction and opposition, which may act harmoniously or discordantly according to the condition of the planets concerned. Two 'malefics' badly placed by sign may cancel out the benefit of a normally harmonious trine between them – you cannot make a silk purse out of a sow's ear! Similarly, well-placed benefics in square to each other are not likely to pose many difficulties.

There are other ways in which planets can be linked together, besides being in aspect. Planets in the same degree of declination, which is the angular distance of a body North or South of the celestial equator, are regarded as being in conjunction, whether or not both are on the same side of the equator. This contact is called 'parallel declination'. The declination of the Midheaven, Ascendant and intermediate cusps may be found by taking the declination of the Sun when in the same degrees. Planets sharing the same declination

may then be regarded as being in conjunction with the cusps concerned.

Planets may also be linked by being in Mutual Reception, that is, by each being posited in the sign ruled by the other (such as Venus in Scorpio; Mars in Libra). One planet in the Antiscion degree of another planet is also linked with that planet as if it were in conjunction with it. The antiscion degree of any body is found by measuring its reflection over the 0° Cancer-Capricorn axis. This is equivalent to a parallel of declination between planets, being based on the fact that the Sun is in its maximum North declination in 0° Cancer and in its maximum South declination in 0° Capricorn. 29° Sagittarius is therefore the antiscion of 1° Capricorn, 28° Sagittarius of 2° Capricorn and so on.

A planet mid-way between two others links all three planets together, even if no recognized aspect already exists between the three.

An aspect between a planet in an earlier sign of the Zodiac to a planet in a later sign is called a sinister aspect. For instance, Mars in 20° Aries is in sinister trine to the Sun in 23° Leo. In this relationship, the Sun is in dexter trine to Mars. An aspect from a planet in a later sign to one in an earlier sign is called a dexter aspect. The earlier planet is regarded as throwing its rays forward on to the later planet. In this case Mars will stimulate and bring out the best of the Sun. Had the Sun been in Aries and Mars in Leo, the Sun might have further inflamed Mars, increasing the difficulties of the contact – although the mutual disposition of the two bodies could be expected to have some helpful effect.

When the distance between two bodies in aspect narrows towards an exact aspect on the days following birth, the aspect is said to be an applying one. When the distance increases, the aspect is called separating. Applying aspects show qualities which are being formed and actively worked upon during the present life. Separating aspects probably denote qualities already developed through past endeavours, even when the aspect is technically a difficult one.

The following interpretations of the effects of planets in aspect are intended as a general guide to delineation. Due allowance should be made for the modifying effects of sign and house position, the nature of the aspect and whether it is dexter or sinister. Unless afflictions are severe and the general condition of the horoscope adverse, the comments in brackets may not apply!

Sun–Moon

Drive, assurance, vitality (low vitality); popularity (unpopular); absence of inner conflict, success (one-sided, self-centred, opinionated, disjointed, lacks perspective); (nervy, irresolute, lacks inner control); successful (inharmonious) marriage.

N.B. The Moon in its first quarter suggests instinctive activity; in the second, a struggle towards fulfilment: in the third, the beginning of a period of assimilation; in its last quarter, problems arising from efforts at realignment.

Sun–Mercury (These can never be more than 28° apart)

Intelligent (unreceptive); ingenious (lacks flexibility, complacent); studious, clear thinking (dogmatic); practical.

Sun–Venus (never more than 48° apart)

Affectionate, sociable, popularity-seeking (affected, parasitic); artistic, refined (effeminate, lacking taste); pleasure-loving (over-indulgent); usually marries (amorous).

Sun–Mars

Power of command (over-assertive); enterprising, energetic (aggressive); courageous (reckless); blunt (quarrelsome); enthusiastic (impulsive, impatient, exaggerating, indignant); crusading (defiant, rebellious); much vitality (fever, accident, inflammation, overstrain); (few children); (trouble to father, husband); nearly always weds.

Sun–Jupiter

Generous (over-expansive); benevolent, optimistic (over-hopeful, superstitious); frank, positive (complacent, conceited); responsible; good judgement (careless); love of luxury (parasitic); rise in life (hinders advancement); financial gain (loss); great vitality (sluggish circulation, need to be abstemious).

Sun–Saturn

Sound, serious (pessimistic); reliable, conscientious, self-controlled, self-critical, honourable, patient, persistent (obstinate); methodical (unpractical); limited, conservative (over-cautious); self-conscious (shrinking, buries talent); ambitious (selfish, miserly, can amass wealth); (many hindrances, restrictions); older husband (women – delay in marriage, death of partner) few children; staying power (chills, poor recuperation).

Sun–Uranus

Strong-willed, dynamic (highly-strung, uncontrollable); independent, progressive (revolutionary); original, inventive, inspirational, unconventional (novelty-seeking); resourceful, decisive, autocratic (tactless, cynical); dramatic sense (self-glorifying); sudden gains (losses); (trouble to father); lengthens life (accidents, nervous ailments); women – romantic attachments (separation, divorce).

Sun–Neptune

Contemplative, intuitive, visionary, imaginative (vague worries); artistic, sensuous (self-indulgent); sensitive (excessive emotion); subtle (secretive, intriguing); humane, idealistic (utopian, irresponsible, unpractical, suggestible, gullible, unstable); speculative gains (tantalizing disappointments); (worry through father); (avoid drugs, alcohol).

Sun–Pluto

Determined (dogmatic); daring (rash, violent); vigorous (quarrelsome); self-confident (boastful, presumptuous); pioneering, reformatory (inner struggles); liberty-loving, strong vitality (blood diseases); (father dies young).

———

Moon–Mercury

Vivifies feelings. Intelligent, perceptive, good (poor) memory, lively imagination (excitable); adaptable (wavering, irregular); changeable (restless); imitative, adroit (careless); easily educated; (danger of slander); clever (restless) wife; (worry affects health).

Moon–Venus

Harmonizes feelings. Gentle (pliable); kind, affectionate (amorous); cheerful, friendly (flirtatious); calm, talented (vain); elegant (slovenly); pleasure-loving (self-indulgent, prodigal); popular, help from (loss through) women; man – happy marriage (slovenly wife).

Moon–Mars

Energises feelings. Courageous (rash, impulsive); resolute (headstrong); energetic (precipitate); constructive (destructive); ardent (passionate, jealous, vindictive); extravagant; assertive (contentious, resents opposition); robust (accidents, fevers); (accidents to mother; wilful wife).

Moon–Jupiter

Expands feelings. Sincere (hypocritical, self-deceived); generous (careless, extravagant); dignified (arrogant); just, joyous (exuberant, self-indulgent); successful; financial gain (loss); healthy (gout, liver, stomach, blood disorders).

Moon–Saturn

Deepens feelings. Serious (hypercritical, sceptical); hypersensitive (feels unappreciated, inadequate); reserved (inhibited, apprehensive, discontented); practical (stupid); industrious, orthodox, careful (mean); patient, self-denying (negative, unresponsive); help from elders (hampers progress); (mother unsympathetic, dies young); older (slovenly) wife; (may deny marriage); few children; (indigestion, poor health).

Moon–Uranus

Stimulates feelings. Highly imaginative, impressionable, intuitive, original (eccentric); magnetic, determined (wilful, touchy, abrupt, intolerant, rebellious, extremist); versatile, unusual interests; women flirtatious; domestic changes; unconventional attachments (unfaithful wife); (nerve strain, accidents).

Moon–Neptune

Inflates feelings. Highly sensitive (retiring, moody); intuitive (negative); imaginative (superstitious); idealistic (dissatisfied, pining); illogical; sympathetic, devotional, altruistic, dreamy, artistic, poetical, musical; luxury-loving (sensuous, parasitic, perverted tastes); persuasive (tricky); easy going (lax); restless (vague, unreliable); strange experiences, inclines to travel; acting talent; (man – unstable marriage, invalid wife); (delicate health, hypochondriac).

Moon–Pluto

Intensifies feelings. Imperturbable (deceptive); humorous (irresponsible); imitative; freedom-loving, adventurous (extremist); perceptive, sentimental; (irritable); (inordinate desires); inclines to travel; (early death of mother, wife); (deep-seated functional disorders).

Mercury–Venus (never more than 76° apart)

Harmonious intellect. Musical, artistic, appreciative, humorous, diplomatic, amiable (easy-going, pleasure-loving); often childless; helpful relatives; healthy nerves.

Mercury–Mars

Energetic intellect. Practical (materialistic); shrewd, resourceful, constructive, quick-witted (restless, hasty, irritable, excitable); forthright (inconsiderate, sarcastic); confident (exaggerating); argumentative (quarrelsome, vindictive); dexterous (careless); often childless; (troublesome relatives); (mental strain).

Mercury–Jupiter

Expansive intellect. Philosophical, judicial (prejudiced); conventional, fertile mind (opinionated, exaggerating); hopeful (bluffing, thoughtless); easily educated; favours travel; helpful relatives; (legal troubles).

Mercury–Saturn

Deepens intellect. Sound, methodical, conscientious, cautious (suspicious); patient, persistent, painstaking (stodgy); sober (pessimistic); studious, logical, conservative (limited); reflective (peevish); organizing; (retiring); (sarcastic); (limited education); (difficult journeys); (handicapped children).

Mercury–Uranus

Stimulates intellect. Progressive (utopian); original, inventive, improvising (erratic, inconstant); alert (opportunist); intuitive, witty (conceited, sarcastic); highly strung (impatient); unconventional (eccentric, opinionated, wrong-headed, perverse); inclines to travel; (disputes).

Mercury–Neptune

Sensitizes intellect. Imaginative (dreamy); fine memory (absent-minded); versatile, subtle (cunning); artistic (unpractical); (morbid, exaltation and depression alternate); perceptive, metaphysical, restless (changeable); travel likely; (slander); (nervous exhaustion).

Mercury–Pluto

Intensifies intellect. Sharp (crafty); quick (opportunist); outspoken

(bluffing, insolent); zealous (fanatical); critical (sceptical, quarrelsome); nimble; travel likely; (asthma, hay fever, nervous breakdown).

Venus–Mars

Stimulates affections. Loving (flirtatious); demonstrative, susceptible (inconstant); passionate, artistic, gay, pleasure-loving (dissipated); early marriage (unhappy affairs, separation, death of partner); affectionate (disappointing) children; (unhappy childhood).

Venus–Jupiter

Expands affections. Kindly, tolerant, generous (extravagant); virtuous (vain); well-balanced (excess of feeling); optimistic, pleasure-loving (self-indulgent, tasteless); financial gain, successful marriage, good health.

Venus–Saturn

Steadies affections. Loyal, sincere (limited affection); (easily rebuffed); modest, chaste (perverted); sound, tactful, economical; (self-seeking); steady gains (money scarce); late marriage or elderly partner (disappointing romances, separation, bereavement); (throat troubles).

Venus–Uranus

Galvanizes affections. Gifted, intuitive, artistic, inspirational, hates routine (erratic); highly romantic (flirtatious, inconstant, jealous, perverted) early romance, hasty marriage (irregular attachments, separation, divorce); many friends (estrangements); sudden gains (loss through women); (scandal).

Venus–Neptune

Refines affections. Inspirational, devoted, dreamy (lives in illusions, unattainable ideals); aesthetic appreciation, artistic talent, susceptible (over-sensitive, sensual, weak, self-indulgent); indolent, over-fastidious (insincere); easy money (fraud); much romance (faithless partner); (delicate constitution, little vitality).

Venus–Pluto

Intensifies affections. Impulsive, artistic, love of beauty (erotic); full emotional life (hypersensitive, infatuated); karmic marriage (amorous intrigues, death of partner).

Mars–Jupiter

Expands energies. Enterprising (reckless); enthusiastic (extravagant); quick-tempered (excitable); optimistic (prodigal); inspiring, evangelistic (sceptical); fair, straightforward (insincere); confident (insolent); resourceful (slapdash); active; money comes, goes easily; physical strength (excesses, excitability deplete powers).

Mars–Saturn

Regulates energies. Self-reliant, courageous (reckless); persistent (fitful); assured (aggressive); hard-working; materialistic (dishonest); unsympathetic (intolerant, vindictive); executive ability (destructive); (many struggles); (unsympathetic father); strong physique (accident prone).

Mars–Uranus

Stimulates energies. Fearless (headstrong); strong-willed (ungovernable, unbalanced); forceful (pugnacious, violent, ruthless); reforming (revolutionary, anarchistic); quick, alert, constructive (destructive); inventive, inspirational (scatterbrained); (forceful enemies); (women – danger of seduction); muscular strength (danger of accidents).

Mars–Neptune

Relaxes energies. Perceptive (obsessed); penetrating (shortsighted); enthusiastic (intemperate, fanatical); emotional (morbid, neurotic); sensuous (coarse); artistic, conceited (self-glorifying); (restless, sensation-seeking); practical charity; (treacherous); (disreputable associates); (women – peculiar attitude to men); (illness through worry, poisons).

Mars–Pluto

Intensifies energies. Combative (hot-tempered, berserk); adventurous (impulsive, foolhardy, criminal); self-confident, strict, unbending (despotic, brutal); relentless (unscrupulous, fanatical, jealous); (ruthless enemies); (accident, illness through poisoning).

———

The following aspects between the slower-moving planets will be within orbs while thousands of births are taking place. They should not be allowed much weight unless either planet is close to an angle, rules the ascendant or is configured with the luminaries, Mercury, Venus or Mars.

Jupiter–Saturn

Tempers enthusiasm. Profound (buried talent); wise, just (severe, cold); religous (narrow, indifferent, materialistic); trustworthy (dishonest); far-seeing; (despondent); steady (restricted) success; profitable (unprofitable) investments.

Jupiter–Uranus

Vivifies enthusiasm. Freedom-loving (undisciplined, autocratic); humanitarian, original (tricky); magnetic, inspiring, intuitive (unbusinesslike); resourceful (discontinuous); metaphysical (novelty-seeking); many changes; rapid gains (speculative upsets).

Jupiter–Neptune

Refines enthusiasm. Idealistic (unsound); devotional, contemplative, sensitive, inspirational, mystical (dreaming, superstitious); emotional (hysterical); over-generous; self-indulgent (weak); conceited; financial ability (loss through fraud).

Jupiter–Pluto

Intensifies enthusiasm. Exuberant (unfulfilled desires); enjoys life (prodigal); dignified (arrogant); freedom-loving (rebellious); inspiring, mature (bigoted); pious (blasphemous); prophetic; robust health.

———

Saturn–Uranus

Stimulates concentration. Serious, pursues Truth (fatalistic); studious, ambitious (frustrated); determined (stubborn); authoritative (always 'right'); practical (persistently wrong-headed); systematic, upright (unscrupulous); prolongs life (chronic illness).

Saturn–Neptune

Refines concentration. Practical (unpractical) ideals; shrewd (calculating); subtle (retiring); honourable (treacherous); opportunist (selfish, egotistical, resentful, discontented); musical; (peculiar tastes); (happiness elusive); (scandal, discredit).

Saturn–Pluto

Deepens concentration. Ambitious (egotistical); tenacious (avaricious); persistent, enduring, self-disciplined (harsh); self-denying, taciturn (suspicious); deliberating; defiant (foolhardy, brutal); (unusual diseases).

———

Uranus–Neptune

Sensitizes will. Deep feelings (emotional intensity); inspirational (deluded); inner assurance (self-critical, obsessed); practical vision (perverse); artistic; seeks excitement (restless, taut); unusual experiences (scandal, disfavour).

Uranus–Pluto

Strengthens will. Highly independent (self-willed); determined (fanatical); authoritative, inventive (eccentric, perverted); can read character; spiritual energy (precipitate, explosive, blind zeal); physical strength, endurance (nervous disorders, paralysis, accidents).

Neptune–Pluto

Intensifies sensitivity. Mystical, fantasy-loving (dream-intoxicated); seeking fulfilment (utopian); penetrative, prophetic, inspirational, dissimulating, craving for adventure (irresponsible, exposed to temptation, base desires).

Casting the Horoscope

IN order to cast a horoscope we need to know the degree of the zodiac that is on the Midheaven, the degree that is rising on the Eastern horizon and how the quadrants of the horoscope so determined are to be subdivided to produce the twelve houses. For this we shall need to know the Sidereal Time of the native's birth and to have Tables of Houses for the latitude of the place he was born in. We shall also need to know the position of the planets in the zodiac so that we can place them in the houses of the horoscope diagram. To do this we shall need to know the Greenwich Mean Time of birth and to have an Ephemeris of planets' places for the year of birth.

As we shall have to deal with at least two different kinds of time (Sidereal and Greenwich Mean) if we are calculating a nativity for London, and with Local Time as well if we are dealing with a birth more than a short distance away from the Greenwich meridian, we shall need to know how these various ways of measuring time are arrived at and how we can change one kind of time to another.

Our twenty-four hour clock day is based on the length of time taken by the Earth to complete one rotation on its axis and return to exactly the same position in relation to the Sun (as, for instance, from the Sun at noon one day to the Sun at noon on the next). Because the Earth is moving in its orbit around the Sun as it rotates it has to make a fraction of a turn farther than one complete rotation in order to establish again the same relationship with the Sun. Because the Earth's orbit is slightly eccentric the length of each day measured on this basis is not quite constant and so we take the average or mean time of the Solar day as our standard, based on the position of the Sun in relation to the Greenwich meridian – hence Greenwich Mean Time. By measuring the Earth's rotation with reference to a relatively fixed point in space, such as one of the fixed stars, we shall obtain a slightly shorter day, giving the basis for Sidereal (Latin *sidus* – star) Time. Our standard day is longer than the Sidereal day by 3 min. 56 sec. and this amount of time, multiplied by the number of days in the year, is equivalent to twenty-four hours of Sidereal Time, or one complete rotation of the Earth. In other words, in twenty-four hours of clock time the Earth turns through about 361°; in twenty-four hours of Sidereal Time it turns through exactly 360°. Because the

EDITOR'S NOTE: These calculation instructions are necessarily abbreviated here. Please see the Appendix for further information on chart calculation and also for information on obtaining computer-calculated charts.

Zodiac is also a full circle of 360° we can use Sidereal Time as a means of indicating which degree of the Zodiac is on the Midheaven at any particular moment and this, as we shall see shortly, is the key factor in using the Tables of Houses.

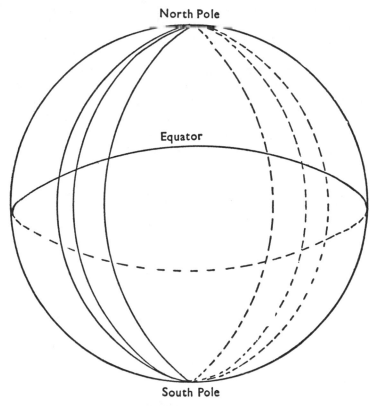

FIG. 2

It is only convenient for countries near the Greenwich meridian to use G.M.T. Other countries use a meridian of longitude nearer their own capital. Meridians of longitude are great circles passing through the poles and cutting the equator at right angles (see figure 2). Measured along the circle of the equator there are thus 360° of longitude. The meridian passing through Greenwich is numbered 0. There are 180° of longitude west of Greenwich and the same number east. As the Earth takes twenty-four hours to turn on its axis it will be seen that each degree of longitude represents four minutes of

clock time. 15° therefore represents an hour and for this reason most standard time meridians are those which are multiples of 15. Vast countries such as the United States and the Soviet Union have several standard time meridians. Births are usually recorded in standard time. Occasionally they are recorded in local time, which is based on the Sun's actual position in the sky at any locality and not upon its position at an agreed meridian, which may be some considerable distance from the birthplace. A further complication arises in those countries where Summer Time is used, when the clock is one hour in advance of Standard Time. *Whitaker's Almanack* gives useful information about time standards and the countries where Summer Time is in use. It also lists the beginning and ending of Summer Time each year in Britain over the years in which it has been operative. Here is a list of countries, showing how the Standard Time in each varies from G.M.T.

Country	Standard Meridian	Hours + or − of Greenwich
Alaska	120 W.	− 8 h.
	135 W.	− 9 h.
	150 W.	− 10 h.
	165 W.	− 11 h.
Algeria	0	0
Argentina	60 W.	− 4 h.
Australia	120 E.	+ 8 h.
	142 E. 30	+ 9 h. 30 m.
	150 E.	+ 10 h.
Austria	15 E.	+ 1 h.
Belgium	0	0
Brazil*	45 W.	− 3 h.
	60 W.	− 4 h.
	75 W.	− 5 h.

Bulgaria	30 E.	+ 2 h.
Burma	97 E. 30	+ 6 h. 30 m.
Canada*	60 W.	— 4 h.
	75 W.	— 5 h.
	90 W.	— 6 h.
	105 W.	— 7 h.
	120 W.	— 8 h.
Ceylon	82 E. 30	+ 5 h. 30 m.
China†	105 E.	+ 7 h.
	120 E.	+ 8 h.
Czechoslovakia	15 E.	+ 1 h.
Denmark	15 E.	+ 1 h.
Egypt*	30 E.	+ 2 h.
Finland	30 E.	+ 2 h.
France	0	0
Germany	15 E.	+ 1 h.
Greece	30 E.	+ 2 h.
Hungary	15 E.	+ 1 h.
India‡	82 E. 30	+ 5 h. 30 m.
Ireland*	0	0
Italy	15 E.	+ 1 h.
Japan	135 E.	+ 9 h.
Jugoslavia	15 E.	+ 1 h.

Mexico	90 W.	− 6 h.
	105 W.	− 7 h.
Morocco	0	0
New Zealand	172 E. 30	+ 11 h. 30 m.
Norway*	15 E.	+ 1 h.
Palestine	30 E.	+ 2 h.
Panama	75 W.	− 5 h.
Poland*	15 E.	+ 1 h.
Portugal*	0	0
Spain	0	0
Sweden	15 E.	+ 1 h.
Switzerland	15 E.	+ 1 h.
Tunisia	15 E.	+ 1 h.
Turkey	30 E.	+ 2 h.
Union of South Africa	30 E.	+ 2 h.
U.S.S.R.§	30 E. to 180 E.	Hourly zones from 2 to 12 hours fast of G.M.T.
U.S.A.†	75 W.	− 5 h.
	90 W.	− 6 h.
	105 W.	− 7 h.
	120 W.	− 8 h.

* Summer Time in use.
† Summer Time in some parts of country.
‡ Except Calcutta – 5 hours 53 min. 21 sec. in advance of G.M.T.
§ Summer Time in operation all the year round.

Unless the native's time of birth is known within fairly narrow limits it is not possible to set up a reasonably accurate horoscope of birth. Few people are able to give their birth time to the minute and even in those countries where it is obligatory to register birth times this is usually done only to the nearest quarter of an hour. An experienced astrologer can usually find the true birth time provided the estimated time is not more than half an hour out. The beginner however, will be forced to rely upon the information given him and he should not be surprised if later researches, based on his growing experience, show that some adjustment to his original figure is necessary. He should learn to be chary of accepting at face value birth times given in round figures – 6.00 a.m., 6.30 p.m., and so on. Very few are born exactly on the hour or half-hour! Even a birth time registered by a stop-watch is not always reliable from the astrological point of view because of the uncertainty as to what constitutes the true moment of birth. Some authorities take the moment of the first cry, others the moment when the umbilical chord is severed. Ancient Hindu astrologers, who taught that the Earth breathed in and out in an eight-minute rhythm, maintained that only certain times during the day could be productive of human births. It may well be therefore that a new baby is not truly 'Earthborn' until that moment of time when its own intake of breath coincides with a peak in the rhythm of the Earth's breathing.*

Having ascertained as nearly as possible the native's birth time, together with his date and place of birth, we are ready to set about the operation of erecting his horoscope. Let us suppose we wish to set up the horoscope of a man born at 2.05 a.m., G.M.T. on 9th October, 1935, in London. In order to do this we shall need a copy of Raphael's 1935 Ephemeris (published by W. Foulsham & Co., Ltd.). First, turn to the page marked 'October'; in the first column in the lower half of the page you will see the actual day of the month given. In the next column is the initial letter of the weekday and in the third column the Sidereal Time at Greenwich for each day at noon, G.M.T. From this third column extract the Sidereal Time for 9th October, which is 13 hours 8 minutes 43 seconds. 2.05 a.m. is before noon, 9 hours 55 minutes before, to be exact. This is 9 hours 55 minutes of clock time and as we require for the moment to work in Sidereal Time we must convert this amount of time to Sidereal Time by adding the necessary increment of 10 secs. (9.84 sec. if you wish to be precise) per hour. We can set out the calculation thus:

*ED. NOTE: Since the mother's memory is notoriously inaccurate, it is still strongly urged that one obtain the actual birth certificate, even if it takes some trouble to do so. It can be obtained from county or state agencies, or from hospital records, if no relative has a copy.

From Sidereal Time at noon on
9th October, 1935 13 h. 08 m. 43 s.
Subtract amount of time before noon at which
 birth took place (9 h. 55 m.) plus increment
 of 10 sec. per hour (1 m. 40 s.) to convert to
 Sidereal Time 9 h. 56 m. 40 s.

Sidereal Time of birth 3 h. 12 m. 03 s.

Had the birth occurred at 2.05 p.m., G.M.T., we should merely have added this amount of time, plus the increment to turn it into Sidereal Time, to the Sidereal Time at noon, thus:

Sidereal Time at noon on 9th October, 1935 13 h. 08 m. 43 s.
Plus amount of time after noon that birth took
 place (2 h. 05 m.) plus increment of 10 sec.
 per hour (20 sec.) 2 h. 05 m. 20 s.

Sidereal Time of birth 15 h. 14 m. 03 s.

From the Sidereal Time of birth we are able to calculate the degree of the zodiac on the Midheaven, and therefore on all the other house cusps of the horoscope. Because the birth we have been considering took place in London and the time of birth was given in G.M.T., which is 'Local Time' at London, we have not needed to make any extra calculation in order to arrive at local time, which is the basis for the calculation of the actual position of the Midheaven. Had the birth occurred at Bristol, which is 2° 40′ West of Greenwich, at 2.05 a.m., G.M.T. we should have had to have subtracted approximately 11 minutes (at the rate of 4 min. per degree) from G.M.T., making the local time of birth 1.54 a.m. (10 h. 06 m. before noon). Adding the necessary increment to convert this to Sidereal Time (1 m. 40 s.) we now find that we have to subtract 10 h. 07 m. 40 s. from the previously stated S.T. at noon on 9th October, giving a S.T. at birth of 3 h. 01 m. 03 s. If the birth had occurred East of Greenwich, a similar correction would have to have been *added* to the G.M.T. of birth.

Further complications arise when foreign nativities have to be calculated, for if the time of birth is given in standard time it is necessary to know the meridian upon which that standard is based

(see table on pages 122–124). If the birth had occurred in New York at 2.05 a.m. E.S.T. the following corrections would have to be made:

Longitude of Standard Time Meridian	75° W.	00′
Longitude of New York	73° W.	57′
Difference (East of Standard Time Meridian)	1°	03′

Add difference in time (at rate of 4 min. per degree of longitude) to Standard Time of birth to give
Local Time of birth 2.09 a.m.
= 9 h. 51 m. before noon, (plus increment of 1 m. 38 s.) to be subtracted from S.T. at noon
Sidereal Time at Noon G.M.T. + 10 sec. for every 15° W. of Greenwich (50 s.) 13 h. 09 m. 33 s.
Sidereal Time of birth 3 h. 16 m. 55 s.

Had the birth occurred at a point West of the time meridian it would have been necessary to subtract the allowance of 4 minutes for each degree of longitude from the Standard Time of birth.

Now let us set up the horoscope for London that we have already begun calculating on page 125. We found that the Sidereal Time of birth was 3 h. 12 m. 03 s. The next step is to take a blank horoscope form (or draw a fairly large circle and divide it into twelve equal segments) and turn to the Tables of Houses for London at the back of the 1935 Ephemeris. Find the times in the column headed 'Sidereal Time' nearest to the time already calculated. They are 3 h. 10 m. 12 s. and 3 h. 14 m. 15 s. in the second group of columns from the left. These two sidereal times are 4 m. 3 s. apart. The Sidereal Time of birth is 1 m. 51 s. later than the earlier of these two times. As one whole degree passes over the Midheaven during the 4 m. 03 s. elapsing between the two Sidereal Times in the table, we want to know what part of a degree will pass over the Midheaven in 1 m. 51 s. 4 m. 03 s. = 243 s.; 1 m. 51 s. = 111 s. The answer will therefore be

$$1° \text{ (or } 60′ \text{ of arc) } \times \frac{111}{243} = \frac{6660}{243} = 27′ \text{ (approx.) (An approximate}$$

method is to take 4 s. as the time for 1′ of arc to pass over the Midheaven. According to this formula, 1 m. 51 s. (111 s.) ÷ 4 = 28′.) 27′ is the amount of arc to be added to the figure in the column next to the Sidereal Time of 3 h. 10 m. 12 s., which is '20'. This column is

headed '10' to show that the degree given is that of the tenth house cusp (Midheaven) and immediately under the '10' is '♉', showing that 20° ♉ is on the tenth house cusp when the Sidereal Time is 3 h. 10 m. 12 s. We therefore add 27' to this degree to get 20° ♉ 27' on the Midheaven at the time of the birth of our subject. Write in these figures above the tenth house cusp of your blank horoscope.

We have now to calculate the exact Ascendant by a similar proportion sum. Under the column headed 'Ascen.' opposite the time 3 h. 10 m. 12 s. we find 0° ♍ 12'. Opposite the later time of 3 h. 14 m. 15 s. in the Ascendant column we find 0° ♍ 54'. The distance between the two positions is 42', which we have to multiply by the same factor

of $\dfrac{111}{243}$ that we used when calculating the interpolated position of the

Midheaven. $42' \times \dfrac{111}{243} = \dfrac{4662}{243} = 19'$ (approx.). Add 19' to 0° ♍ 12'

to give 0° ♍ 31' as the Ascendant. Place this figure by the first house cusp of your horoscope figure. Because the intermediate house cusps are only given to the nearest degree it is not advisable to attempt to calculate their exact positions on the basis of the figures given in the Tables. Instead, taking the Sidereal Time nearest to birth, 3 h. 10 m. 12 s., read across the columns headed '11', '12', '2', '3', to find the degrees to be inserted against the eleventh, twelfth, second and third house cusps. These figures are 28, 3, 20, 16. To find which signs these degrees belong to let your eye travel up the appropriate column until you see a sign glyph. The first you see is the one you must take, for the signs on the intermediate house cusps do not all change at the same time and the sign at the top of the column is not necessarily correct as the Sidereal Time gets later. The degrees we need are therefore 28°♊, 3°♌, 20°♍ and 16°♎. Write in these figures and signs against the vacant cusps on the left-hand side of the horoscope figure, beginning with the eleventh cusp just below and to the left of the Midheaven. Now all that remains to be done is to enter the opposite degrees of the zodiac against the six remaining cusps; 20° ♏ 27' on cusp four, 28°♐ on cusp five and so on. You will see that the signs ♋ and ♑ do not appear on any cusp but fall in the natural order of the signs in the eleventh and fifth houses. Place these intercepted signs in the rim of the wheel in between the eleventh and twelfth and fifth and sixth cusps. The figure should now look like this (see Figure 3).

We have now to calculate the places of the Sun, Moon and planets

and insert these in their proper places in the horoscope. Turn to the pages in the Ephemeris marked 'October, 1935'. In the lower half of the left-hand page you will see that the first column gives you the day of the month, the second the name of the day, the third the Sidereal Time at Noon at Greenwich, and the fourth and sixth columns the longitude of the Sun and Moon at Greenwich Noon to the nearest

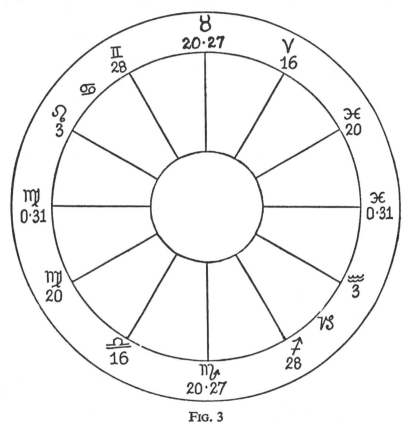

Fig. 3

second of arc. On the lower right-hand page the first column repeats the day of the month and the second to the seventh columns give the planets' longitudes for Greenwich Noon, from Neptune to Mercury. Just above the column for Mercury, in the upper half of the page, is a column giving the mean position of the Moon's North Node (which moves backward through the Zodiac) for every second day. The approximate longitude of Pluto is given at the foot of the left-hand

page for the beginning of the month only. In more recent ephemerides a more detailed schedule of Pluto's movements is included.

Our first task is to find the amount of arc travelled by each body in the twenty-four hours that includes 2.05 a.m. on 9th October, 1935. To do this we shall need to observe the longitude of each body on the previous noon and subtract this figure from the longitude of each body at noon on 9th October. A table of the daily motions of the Sun, Moon, Mercury, Venus and Mars, the fastest moving bodies, based on their motion from midnight to midnight, is given in the back

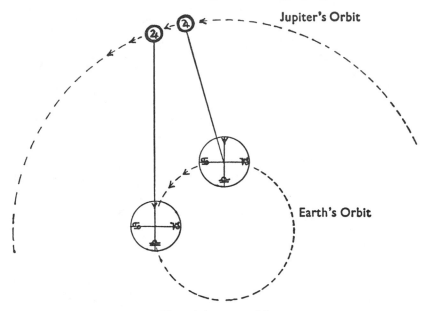

FIG. 4 (*not to scale*)

of the Ephemeris. Next, we shall have to calculate how far our birth-time is from noon and what proportion of the daily motion takes place during that period. 2.05 a.m. is approximately 10 hours before noon on 9th October, so we have to divide each daily motion by 24 (hours) and multiply it by 10 to get the figure we need. As the time of birth is before noon we shall have to *subtract* the result in each case from the longitude given for noon on 9th October *unless the planet is Retrograde* in which case the increment must be added. (A planet is retrograde when it appears to go backwards in the Zodiac, due to the motion of the Earth in its orbit (see Figure 4). The opposite of

retrograde is 'direct' and a planet changing from one direction to the other is temporarily 'stationary'). Once the planet's position has been calculated, observe which house cusps form the boundaries of the area in which the planet falls and then insert it in the appropriate house. Because the Moon's motion is so much faster than that of any other body, her position is more easily and accurately calculated by the use of four figure logarithms, which are to be found on the last page of the Ephemeris. On p. 132 in tabular form is a demonstration of the calculation of the planets' places and the houses in which they fall.

Pluto (not included in the table) is in 27° ♋ 14′ on 1st October and in 27° ♋ 25′ ℞ on 1st November, giving a motion in 31 days of about 11′; say 3′ in 8 days – longitude of Pluto on 9th October, 27°♋17′. Remember, where necessary, to add the symbol ℞, when entering the planets in the horoscope. (This symbol indicates *retrograde*.)

It now only remains to calculate the Moon's position. First obtain the Moon's daily motion to the nearest minute by subtracting the Moon's longitude at noon on 8th October, 22° ♒ 23′, from the Moon's longitude at noon on the 9th, 7° ♓ 09′. This gives 14° 46′ as the required figure. Remembering that birth took place 9 hours 55 minutes before noon we can now make the following calculation:

Add log. of Moon's daily motion (14° 46′)	2109
to log. of time from noon (9 h. 55 m.)	3838
	————
	5947
	————

(To find the log. for any combination of degrees and minutes or hours and minutes – up to a maximum of 15 degrees (hours) 59 minutes – read along the horizontal column headings for degrees or hours, and down the vertical headings for minutes to arrive at the exact point in the column required.) We now have to find the figure nearest to 5947 in the columns of logs. It is 5949 in the 6 degree column and opposite '6' in the minutes column, so that the arc we require is 6° 6′. As birth took place before noon we must remember to subtract this amount of arc from the Moon's longitude at noon on 9th October (7° ♓ 09′). The required longitude is therefore 1° ♓ 03′, which places the Moon in the seventh house between the cusp and Saturn. If there are several planets in one house, enter them in the proper sequence of the degrees they occupy.

Planet	Longitude at Noon		Difference (Daily Motion)	$10 \times \dfrac{}{24}$	Subtract from Noon position 9th Oct.	House Cusps on either side		House
	9th Oct.	8th Oct.						
☉	15°≏16'	14°≏17'	59'	25'	14≏51'	(2)	20° ♍	2
						(3)	16° ≏	
☿	2°♏07'	2°♏29'	22'	9'	2°♏16' (add)	(3)	16° ≏	3
						(4)	20° ♏	
♀	8°♍22'	8°♍02'	20'	8'	8°♍14'	(1)	1° ♍	1
						(2)	20° ♍	
♂	15°♐58'	15°♐15'	43'	18'	15°♐40'	(4)	20° ♏	4
						(5)	28° ♐	
♃	23°♏36'	23°♏24'	12'	5'	23°♏31'	(4)	20° ♏	4
						(5)	28° ♐	
♄	4°♓14'	4°♓16'	2'	1'	4°♓15' (add)	(7)	1° ♓	7
						(8)	20° ♓	
♅	4°♉14'	4°♉17'	3'	1'	4°♉15' (add)	(9)	16° ♈	9
						(10)	20° ♉	
♆	15°♍28'	15°♍26'	2'	1'	15°♍27'	(1)	1° ♍	1
						(2)	20° ♍	
☋	17°♑20'	17°♑27*	7' (÷2)	3' (÷2)	17°♑21' (add)	(5)	28° ♐	5
					1'	(6)	3° ♒	

* Position on 7th October.

Finally, we need to calculate the longitude of the Part of Fortune, according to the following formula: Longitude of Ascendant + Longitude of Moon — Longitude of Sun. First write the number of the sign, then the degrees, then the minutes of each factor:

Asc.	6 signs	0°	31'
+	12 signs	1°	03'
	18 signs	1°	34'
—	7 signs	14°	51'
	10 signs	16°	43'

The tenth sign is Capricorn and so the Part of Fortune (⊕) is in 16° ♑ 43' and therefore falls between the fifth cusp and the Moon's

Fig. 5

North Node. Our completed horoscope should now look like Figure 5.

We are now ready to tabulate the aspects. First start with the Sun and observe in turn whether it throws any aspects to the Moon, Mercury, Venus, Mars, Jupiter, Saturn, Uranus, Neptune, Pluto, Midheaven, Ascendant, the Nodes and Fortuna, in that order. With practice you will get to recognize aspects at a glance but at first you may have to work them out rather laboriously. The table (p. 137) shows the longitudinal distance between all the planets and the aspect, if any, between each pair.

Saturn's sesquiquadrate to the Sun is weak but allowable as there is a fairly close sesquiquadrate between the Sun and Moon and the Moon is conjunct Saturn. For a similar reason Uranus may be regarded as being trine Ascendant. As Mercury and Venus are fast moving planets and are at the extreme limits of a sextile, this aspect may safely be disregarded. Aspects to the Nodes and Fortuna should not be more than 3° short of exactitude. Our table of aspect distances allows us to see fairly easily if any planet stands midway between any other two. Mars is 138° from Uranus on one side and 139° from Pluto on the other and therefore stands about midway between them. Jupiter is midway between Mercury and Mars.

We have now to find out if there are any parallels of declination and our preliminary survey of the horoscope is concluded. Planetary declinations are given for every second day in the case of Neptune, Uranus (called Herschel in the Ephemeris), Saturn and Jupiter, and for Mars, Venus and Mercury for every day at Greenwich Noon. These will be found, in alternate columns with the latitude of the planets (the perpendicular distance of a planet north or south of the ecliptic), in the upper half of the two pages for October, 1935. As when calculating planetary longitudes, subtract from the noon declinations of the planets on 9th October the declinations for 8th October (or 7th where only these are given) and multiply by the factor used before $\left(\dfrac{10}{24}\right)$, or $\dfrac{10}{48}$ in the case of two days' motion, and add the result to or subtract it from the noon position on 9th October, according to whether the declination is decreasing or increasing. The daily declinations of the Sun and Moon appear in the lower half of the left-hand page. The calculations may be tabulated thus:

Planets	Declination			Difference *	$\times \dfrac{10}{24}$	$\times \dfrac{10}{48}$	Add to or subtract from declination on 9th Oct.
	9th Oct.	8th Oct.	7th Oct.				
☉	6°S. 01′	5°S. 38′	—	23′	10′	—	5°S. 51′
☽	5°S. 21′	11°S. 21′	—	6° 00′	2° 30′	—	7°S. 51′
☿	15°S. 22′	15°S. 34′	—	12′	5′	—	15°S. 27′
♀	4°N. 36′	4°N. 32′	—	4′	2′	—	4°N. 34′
♂	24°S. 11′	24°S. 06′	—	5′	2′	—	24°S. 09′
♃	17°S. 58′	—	17°S. 52′				17°S. 57′
♄	11°S. 45′	—	11°S. 43′	The daily variation in the declination of these planets is so slight that their positions can be calculated visually from the Ephemeris			11°S. 45′
♅	12°N. 27′	—	12°N. 28′				12°N. 27′
♆	6°N. 37′	—	6°N. 38′				6°N. 37′
♇	22°N. 39′	—	—				22°N. 39′

* If a planet changes from North to South declination, the two daily figures should be added together and not subtracted.

The declination of the Midheaven, Ascendant and Fortuna is found by taking the declination of the Sun when in the same degree and minute:

	Longitude	Nearest Solar Longitude	Daily Motion	Difference in Longitude	Daily Motion of Declination	$\times \dfrac{\text{Difference}}{\text{Daily Motion}}$	Result	Add to or subtract from Noon declination
		1935						
M.C.	20°♉ 27′	12th May 20°♉ 50′	58′	23′	15′	$\dfrac{23}{58}$	6′	17°N. 52′
Asc.	0°♍ 31′	24th Aug. 0°♍ 23′	58′	8′	20′	$\dfrac{8}{58}$	3′	11°N. 17′
Fortuna	16°♑ 43′	7th Jan. 16°♑ 16′	61′	27′	7′	$\dfrac{27}{61}$	3′	22°S. 24′

We have now to find if any of the declinations are within a degree of each other. It makes no difference whether the declinations are North or South. These are the parallels we should include:

M.C. ∥ ♃; Asc. ∥♄ ∥ ♅; ☉ ∥ Ψ; ♀∥ ⊕.

Our final tabulation of aspects will therefore look like this:

☉ ⊼ ☽ SQ ♀ ⚹ ♂ ⊼ ♄ ⊻ ∥ Ψ □ ♌ □ ⊕ BQ M.C. ∠ Asc.

☽ △ ☿ ☍ ♀ □ ♃ ☌ ♄ ⚹ ♅ BQ ♀ ∠ ♌ ∠ ⊕ ☍ Asc.

☿ ∠ ♂ △ ♄ ☍ ♅ ∠ Ψ □ ♀ ⚹ Asc.

♀ □ ♂ ☍ ♄ △ ♅ ☌ Ψ

♂ ⊼ ♅ □ Ψ □ ♀ ⊻ ♌ ⊻ ⊕ (♂ = ☍ ♅/♀)

♃ △ ♀ ☍ ∥ M.C. (♃ = ☿/♂)

♄ ⚹ ∥ ♅ ☍ ∥ Asc.

♅ ⊼ Ψ □ ♀ △ ∥ Asc.

Ψ ∠ ♀ △ ♌ △ ⊕

♀ ∥ ⊕

♌ ☌ ⊕ ⊼ Asc.

⊕ ⊼ Asc.

The data we have been working on is that for the birth of the present Duke of Kent.

Finally, a word about casting horoscopes for places in the Southern hemisphere. Calculate the Midheaven degree in the usual way, add six whole signs (one hemisphere) to the result and, using the Tables of Houses for the corresponding latitude in the Northern hemisphere, calculate the Ascendant in the usual way for this adjusted Midheaven. This Ascendant will be the Descendant of the horoscope you need and the cusps given for the eleventh, twelfth, second and third houses must instead be used for the fifth, sixth, eighth and ninth houses. The Midheaven will be the degree originally calculated before adding six signs.

Planet Longitude	⊕ 17♑	☊ 17♑	Asc 1♍	M.C. 20♉	☋ 27♋	♆ 15♍	♅ 48	♄ 4♓	♃ 24♏	♂ 16♐	♀ 8♍	☿ 2♏	☽ 1♓
☉ 15♎	92 □	92 □	44 ⊼	145 BQ	78	30 ⊼	161	139 □	39	61 ✶	37 SQ	17	136 □
☽ 1♓	44 ⊼	44 ⊼	180 ☍	79	146 BQ	166	63 ✶	3 ☌	97 □	75	173 ☍	119 △	☽ 1♓
☿ 2♏	75	75	61 ✶	162	95 □	47 ⊼	178 ☍	122 △	22	44 ⊼	54	☿ 2♏	
♀ 8♍	129	129	7	108	41	7 ☌	124 △	176 ☍	76	98 □	♀ 8♍		
♂ 16♐	31 ⊼	31 ⊼	105	154	139 □	91 □	138 □	78	22	♂ 16♐			
♃ 24♏	53	53	83	176 ☍	117 △	69	160	100	♃ 24♏				
♄ 4♓	47	47	177 ☍	76	143	169	60 ✶	♄ 4♓					
♅ 48	107	107	117 △	16	83 □	131 □	♅ 48						
♆ 15♍	122 △	122 △	14	115	48 ⊼	♆ 15♍							
☋ 27♋	170	170	34	67	☋ 27♋								
M.C. 20♉	123	123	—	M.C. 20♉									
Asc 1♍	136 □	136 □	Asc 1♍										
☊ 17♑	0 ☌	☊ 17♑											

Judgement of the Horoscope – Preliminary Considerations

THE only way to acquire the ability to delineate a horoscope accurately is through application and hard work. A thorough knowledge of the significance of planets, signs, houses and aspects is a necessary prerequisite and the student should attempt to apply this knowledge to as many horoscopes as he is able to come by. Well-known individuals whose biographies are available are the best for this purpose. There are some whose psychic faculties give them special insight into the interpretation of a nativity. Such gifts may be very useful when the student has thoroughly mastered the art of logically deducing the message of the horoscope but until such time it is wise to eschew any attempt to by-pass the reasoning faculties, otherwise progress in methodically working out a balanced judgement of the birth chart will be stultified. Whereas few are gifted with sufficient sensitivity to receive true psychic inspiration, most students will find that by concentrating upon a rational approach to the problems of horoscope interpretation they will gradually enhance their own intuitive powers.

The principal need in interpreting a horoscope is to determine where the main emphasis lies. The most important factors in determining such emphasis are the angles of the chart (Ascendant, Descendant, Upper and Lower Meridians). Any planet placed exactly on an angle has immense power. Next to these are planets in strong close aspect to an angle, especially those in square to it. Planets in angular houses are also prominent on this account and special attention should be paid to any planet in the fourth house (the subconscious urge behind all action – just as the tenth house shows the conscious urge). The Moon, as the natural ruler of the fourth house, also gives a clue to the natural instincts and its condition by sign, house and aspect will provide further information on this score.

Next, notice whether the horoscope is well integrated, that is whether all the planets are linked together by aspect in some kind of general complex. It will sometimes be possible to distinguish two or three separate groups of planets, connected amongst themselves but

each group unlinked with the other. In such cases judge that the native himself is not properly integrated, that is, has not the power to establish effective links between the various parts of his being and awareness. A well-integrated horoscope provides an inner balance that can offset a number of technical afflictions. A disintegrated chart may pose special problems on that account alone.

An unaspected planet is to all intents and purposes a 'dumb note'. The native has not been able to integrate the qualities it represents with the rest of his being and so has no means of expressing them effectively through his faculties or of combining them with other qualities to the mutual advantage of each.

Contradictory indications in different sectors of the horoscope do not cancel each other out. They usually pull the native in two different directions, causing inner friction, or one set of qualities may be more active and so conceal the existence of the other.

Remember that the closer an aspect is to exactitude the more effective it is likely to be. An almost exact semisextile may be stronger than a sextile between planets five degrees apart. Don't pay too much attention to the nature of an aspect. Planets well fortified by sign can withstand a square or two, while planets in fall or detriment are apt to spoil trines and sextiles. Too many malefics blended by aspect, whether technically harmonious or not, are apt to prove troublesome, while well-placed benefics can bring benefits even when in square or opposition.

An opposition between two planets with a third in sextile to one body and in trine to the other can cause the forces represented by the planets in opposition to function harmoniously through the agency of the third. Similarly, a planet in square to both axes of an opposition can create a dynamic tension that is very difficult to resolve unless there is a fourth body in favourable aspect to one of the other three. Planets in trine, with a third body midway between them in sextile to both, forming a fan-shaped complex, function very easily and harmoniously together, while three bodies in trine to each other (forming a Grand Trine) provide the basis of a great impetus which needs to be carefully controlled if it is not to 'run away' with the native. Much depends upon the nature of the bodies comprising this configuration. Four planets in square to each other on the arms of a cross (forming a Grand Cross) can be a great source of dynamic strength having much stabilizing influence, provided an harmonious release of energy is afforded by a planet in good aspect to one of the four arms of the cross. Minor stresses may be set up by a planet in

sesquiquadrate and semisquare respectively to the two poles of an opposition, while minor benefic complexes can result from three or four planets equidistant by thirty degrees.

A good deal can be learnt from the actual patterns formed by the planets amongst themselves, irrespective of the precise aspectual relationship between them. An American astrologer, Marc Edmund Jones, has devoted a whole book to this subject (*A Guide to Horoscope Interpretation*) and students who wish to enlarge their knowledge of his ideas are recommended to acquire this work.

Briefly, he distinguishes seven types of pattern. All planets grouped together between the containing confines of a trine (or lesser area) produce the Bundle, a grouping which precludes any responsiveness to stimuli from without, narrows the interests, creates inhibitions but develops opportunism and self-sufficiency and gives the power to capitalize with surprising effectiveness upon limited resources.

All planets spread out within a half-segment of the circle (contained by an opposition), produce the Bowl, a grouping which indicates a very self-contained individual with great inner resources, who nevertheless feels cut off from a whole segment of experience. Such a pattern produces a sense of agency and a tendency to initiate schemes for the well-being of his fellows if the planets are below the horizon, or to consummate such schemes if the planets are above.

Where all planets but one (or two together) form a Bowl and the other stands alone in the other hemisphere of the Zodiac, a Bucket is formed. The planet thus isolated represents a special capacity for some specially significant activity which gives a compelling orientation to the whole life so that the individual is able to become a source of inspiration or merely an agitator, according to his development.

The See-Saw pattern, as its name suggests, is made up of two groups of planets ranged about opposite signs or pairs of signs. The individual is subjected to two directly opposed types of experience, producing an awareness of conflict which either enables him to strike a happy medium or causes him to struggle perpetually with diametrically opposed urges.

Where the planets are spread more or less evenly over two-thirds of the circle, leaving an empty trine, the Locomotive pattern is formed. There is a strong sense of lack which produces an inner compulsion to seek fulfilment. There is much executive ability and often self-seeking.

When the planets are distributed more or less evenly over the

whole circle, the Splash pattern is formed, showing an uninhibited personality with universal interests who either scatters his energies indiscriminately or organizes them on the widest possible basis.

Where the planets cannot be arranged conveniently into any one of the foregoing patterns but are distributed less regularly round the circle we have the Splay, usually based on three points of emphasis, which may be a Grand Trine. Such a pattern denotes an individual's ability to entrench himself in his own stronghold so that he always has something to fall back upon. He is likely to be a sturdy individualist and sometimes a ruthless one.

The total effect of the planets may also be estimated in other ways. Note how many planets are in Cardinal signs, how many in Fixed, and how many in Mutable. Then make a similar list according to the element tenanted. A majority of planets in Fixed and Fire signs will cause the native to exhibit the qualities of the Fixed Fire sign Leo, irrespective of the actual bodies in this sign. If an equal number of bodies are in Cardinal and Fixed signs and the Ascendant is in a Cardinal sign, give the greater emphasis to the Cardinal Quadruplicity. Similarly if the number of bodies is equally poised between signs of different elements. If it is not possible to make any distinction on this basis, allow for an equal accent on different qualities or elements. Just as the accentuation of one quality or element may be significant, so is the lack of one. A horoscope without planets in fire may indicate an individual without real warmth or enthusiasm, although this may be largely compensated by an angular Sun, Mars or Jupiter or by mutual configurations between these bodies. Judge similarly according to other deficiencies of element or quality.

Several bodies in one sign (a satellitium) always place a strong emphasis on that sign and also upon the planet ruling the sign, the dispositor of the satellitium. Observe also, if any one planet disposes finally of all the other planets. For instance, if the Sun is in Cancer, with Mars, Mercury and Venus, the Moon is the dispositor of these planets. Look then to see which planet disposes of the Moon. If the Moon is in Sagittarius, with Saturn and Uranus, Jupiter will dispose of these three bodies and, through the Moon, of the planets in Cancer. If Neptune is in Scorpio and Pluto in Virgo, their dispositors will be Mars and Mercury in Cancer, already noted as being disposed of by the Moon in Sagittarius, which is disposed of in turn by Jupiter. This leaves only Jupiter unaccounted for. If he should be placed in Pisces, his own sign, he will therefore be the final dispositor of all the bodies in the nativity. The final

dispositor necessarily, will be a planet placed in its own sign. In this case it would be wise to consider whether a special emphasis should not be given as well to Neptune, also dignified in Pisces, although it is not equally the final dispositor, being itself disposed of by Mars.

Other ways in which a planet may receive a special emphasis are by it receiving aspects from both luminaries, by its elevation over all the other planets and by its conjunction with the Part of Fortune or with the Moon's Nodes. A planet connected by aspect with both the Sun and Moon shows a response to that planet on two significant levels, the individual and the personal, giving it an essential as well as an instinctive significance. The conjunction of Fortuna with a planet also establishes a similar kind of relationship at an ideal level, because the Part of Fortune is a point which depends upon the Sun-Moon-Ascendant relationship. It is in fact the place where the Moon would be if the Sun were exactly on the Ascendant. Such a solar position implies perfect alignment between the Inner Man and his outer vehicle, the illumination symbolized by the rising Sun at dawn. Fortuna therefore indicates the type of personal adjustment necessary in order to bring about this illumination. Planets in closest aspect to the Part of Fortune therefore show which attributes of character may best be brought into play to bring about such a symbolic illumination.

The position of the Moon's Nodes also marks another important axis in the nativity from the point of view of self-development. This axis also has a Sun-Moon-Earth relationship as its background, for the Nodes mark the point at which the path of the Moon intersects the path of the Earth round the Sun (the ecliptic). Planets close to the North (positive) Node of the Moon show qualities to be consciously developed during the life; planets close to the South (negative) Node of the Moon indicate qualities developed in past lives that are now habitual and therefore require little effort to bring into play. The Moon's North Node (Caput Draconis) can also be regarded as the first point of a Lunar Zodiac. Planets between the Dragon's Head (Moon's North Node) and the Dragon's Tail (South Node) in the order of the signs show new faculties which may be developed. Planets in the opposite hemisphere indicate the working out of past tendencies. The dispositors of the Nodes can further amplify the evidence, while applying aspects also show new qualities being built up and separating aspects, qualities already part of the character. For that reason applying aspects are probably more

critical. An example of the use of the Moon's Nodes in delineation is given in Chapter Nine.

The distribution of the planets in the hemispheres of the horoscope marked off by the Ascendant-Descendant axis and by the Meridian axis is also significant. When the majority of the planets are in the Eastern half of the chart, this places an emphasis upon the native's initiative, giving him more opportunity to exercise his will in the ordering of events, usually through conscious endeavour. A majority of planets setting, on the Western side of the horoscope, denotes that the life is largely in the hands of other people. There is a good deal less opportunity to control destiny, so that an attitude of acceptance is desirable. This accentuates the feeling side of the nature.

The majority of planets above the horizon produces a great preoccupation with externals, giving extrovert tendencies and an objective viewpoint. Ambition and self-reliance are generally well in evidence. When the situation is reversed and the majority of planets are below the horizon the native's experiences are largely subjective and he relies mostly on his instincts. Intuitions are usually well developed and an introvert tendency is likely.

If all the planets except one are in one hemisphere, the planet in the other hemisphere assumes considerable significance for it is as if the native were trying to balance that part of himself represented by the majority of planets by the single faculty denoted by the remaining planet. If all but two planets are located in one hemisphere it often seems that there is a close relationship between the two isolated planets, irrespective of whether they are linked by aspect or not. The planet highest in the heavens (most elevated) that is, nearest to the Midheaven, no matter whether it is to the East or West of the Upper Meridian, enjoys a certain prominence on that account. It must not be regarded as more powerful than a planet close to an angle (although if there are several angular planets the one closest to the Midheaven will enjoy extra prominence for that reason) but if there is otherwise no great emphasis given to any particular planet the most elevated one may be given precedence.

The planet ruling the sign on the Ascendant must always be included in any list of important planets, and special notice paid to its condition by sign, house and aspect. It will often happen that the same planet or couple of planets is accentuated in different ways, so that an obvious emphasis is created. Where this is not the case it is sometimes necessary to proceed a little more cautiously before finally deciding where the main emphasis lies. The three cardinal

factors in delineation are the Sun, Moon and Ascendant, to which should probably be added the ruler of the Ascendant. Where no other specific emphasis is apparent it is wisest to rely on these.

When delineating, remember that the planets represent psychological urges, different types of energy to be used. The signs indicate the manner in which these energies are used, the way in which they are modified. The houses show the special direction in which these conditioned energies are orientated, the departments of life where the planetary urges find their practical working out.

The native projects himself upon life in his own individual way. He identifies himself with the degree of the zodiac upon the Ascendant, the symbolic First Degree of Aries. It is most probable that the actual first degree of Aries will be found elsewhere in the horoscope. It will therefore be seen that every individual makes his own special alignment with the zodiac causing some degree of displacement to take place. This causes him to make a corresponding displacement in all the other departments of the horoscope. Aries, the natural first house sign, may fall on the cusp of the fifth, showing the real inner focus of self-identification is with the things signified by the fifth house instead of (ideally) with the things related to the first house. The urge to associate freely, represented by the sign Gemini, may then be displaced to the cusp of the seventh house (partnership) suggesting a tendency to more than one marriage. The subconscious urges, represented by the planets, are projected into the various houses of the horoscope so that Saturn (feeling of insecurity) in the seventh, may show that the native feels a basic lack of confidence in his ability to carry out the duties of a partner.

By thinking in a certain way we attract to ourselves a corresponding environment. We also tend to draw into our environment people whom we can identify with the various characteristics in our make-up, so that those with Saturn in the seventh may automatically attract to themselves someone of a saturnine disposition, or very much older in years, who personifies their own uncertain and possibly over-serious attitude to seventh-house matters. This kind of identification is very much a matter of subconscious activity, so that our conscious mind is rarely aware of the true nature of affairs. Most of us have some ruling passion that in the last resort colours all our actions in a certain way. This is shown by the house cusp on which the sign Aries appears, so that if Aries rules the second house, the native's whole outlook is coloured by his attitude to possessions,

which can be further defined by the condition of Mars by sign, house and aspect in the horoscope.

Remember also that we suffer from the defects of our virtues. Too much of a good thing may be as much of a handicap as not enough. Always try to assess the balance of the horoscope. There may be a stress on one set of qualities because these qualities have not been adequately developed in the past. Very Martian indications may point to the fact that the native has been too lethargic and unassertive in the past. A clue to past tendencies is given by the position of the Moon's Nodes.

Finally, when delineating a chart, remember that the stars incline, they do not compel. Strong afflictions do not necessarily indicate bad character, although they may indicate a difficult life. It has been said that the Wise Man rules his stars, the fool obeys them. As Alan Leo points out in his *Esoteric Astrology*, the houses in the abstract sense represent limitations in space; the signs, limitations in time; the planets, Causality. Those who rule their stars are those who are no longer subject to the three great illusions of space, time and causality – those who live in the Eternal. In the words of the poet:

One ship drives east, another west, with self-same winds that blow,
'Tis the set of the sails and not the gales that determine the way it shall go.
As the waves of the sea are the ways of Fate as we journey along through life,
It's the set of the Soul that decides its Goal and not the calm or the strife.

Judgement – Particular Considerations

BEFORE delineating a nativity it is advisable to estimate the probable length of life in order to avoid such pitfalls as referring to conditions in old age in cases where the native may die prematurely. Usually fire signs ascending give the greatest hold on life, then air, earth and water, in that order. Mutable signs have less staying power than cardinal or fixed. With certain reservations, relative sign strength can be assessed as follows: Aries, Leo, Sagittarius, Libra, Taurus, Gemini, Virgo, Scorpio, Cancer, Capricorn, Aquarius, Pisces. Great vital force is centred in the sign Leo, so that an infant coming to birth at a time when there are heavy afflictions to the Ascendant or luminaries in this sign may be unable to cope with so much power and may die at birth. However, once the native is well established physically the vitality of Leo is strongly preservative. Sagittarius is rather prone to accident; Taurus gives good vital powers sometimes vitiated by laziness and self-indulgence; Virgo often manifests an interest in physical fitness which is maintained through conscientious exercise and dieting. Scorpio gives a tenacious hold on life but is rather prone to infection. Capricorn does not give great vitality but once the Capricorn native has outgrown his early weakliness he stays the pace better the older he grows and may live to a ripe old age. Air-sign natives are usually less robust but look after themselves carefully. They are liable to nervous exhaustion.

Planets placed in strong signs can survive considerable affliction. Many afflictions involving weak signs may give much trouble in infancy but the native will often grow stronger as the years go by. Many afflictions in weak signs, however, usually denote a short life. The Sun represents the radical constitution, the Moon the functional and sympathetic system, so that afflictions to the Sun are usually more serious than afflictions to the Moon.

Long life may be predicted when the Sun, Moon and Ascendant and its ruler are all unafflicted and in strong signs. When all four are weak by sign and badly afflicted, a very short life is likely. The worst afflictions are from malefics, especially those which occupy or rule the fourth, sixth, eighth or twelfth houses. Any benefic aspect,

146

especially those from Venus, Jupiter and Mars, helps to support life. A well aspected and angular Venus or Neptune brings a capacity to relax that can save the physical vehicle from a good deal of wear and tear. A good Venus also denotes efficient kidneys and therefore the power to rid the body of poisons easily. A strong Jupiter, although protective, may lead to excesses. Any aspect between the Sun and Mars is good for vitality but adverse aspects show a tendency for the native to burn up his resources too quickly. Good aspects from Saturn and Uranus to the Sun are very helpful in old age but have comparatively little effect in youth.

Death in infancy is most often shown by planets in square and opposition close to the Midheaven and Ascendant axes of the horoscope. A child will often survive serious afflictions to the luminaries only. When both luminaries are angular and afflicted by a malefic the child may be short-lived unless a benefic offers strong support. It is not advisable to apply these suggestions too rigidly, for there are cases on record of twin births, where one infant has died at birth and the other survived to live to a ripe old age. In such cases, the exactness of the afflictions to the angles has been the crucial factor.

Planets in the eighth house are infrequent in cases of longevity, as are squares of Saturn or Mars to either luminary. Sun square Uranus, however, is not unlikely in cases of long life. Good aspects from the benefics are most helpful in preserving life.

Physical Appearance

The judgement of physical appearance from the horoscope is often a somewhat complicated affair and a detailed treatment of the various factors involved is beyond the scope of the present volume.

Generally speaking, cardinal signs rising give a triangular-shaped face, narrowing at the chin; fixed signs a squarish face (more oblong with Aquarius); mutable signs an oval face. Positive signs rising usually produce a taller body than the negative signs. Sign characteristics may be much modified by planets near the Ascendant or in strong close aspect to the rising degree. In addition, the Sun sign, Moon sign, and that containing the ruler and any strong satellitium may also play a part in determining the native's appearance, in which a blend of several sign influences can often be traced.

Mental Characteristics

It is not possible to judge from the horoscope the amount of

intelligence possessed by the native, only the type of mentality and the general approach to intellectual activities. This is shown by Mercury, according to its sign and house position and the aspects it receives. The planet throwing the closest aspect to Mercury is the most important as Mercury is very much coloured by its contacts with other planets and by the sign it is in.

The Moon rules the brain and any aspect between the Moon and Mercury is good for mental expression, particularly the square or opposition, although these aspects make for difficulty in concentration. The Moon and Mercury in strong, close aspect to many planets give much versatility.

Many bodies in mutable and air signs and cadent houses are likely to produce a quick, intelligent mind. The inventive Uranus has a great effect on intellect and if this planet is prominent and well aspected there may be good mental capabilities even if Mercury is not prominent or well aspected. Sextile aspects seem considerably to enhance the native's ability to express himself. A good Saturn or several planets in earth usually shows a good measure of common sense, while a prominent well-aspected Jupiter gives good judgement and sometimes wisdom.

Equally important is the condition of the third and ninth houses, the sign on the cusp of the third, planets in the third and ninth houses, the aspects they receive, and the condition of the ruler of the third house. Severe afflictions to planets in the third or to the third house cusp can denote mental instability and, in extreme cases, insanity. A much-afflicted Moon is nearly always present in such cases.

The rising sign and planets in the first house, governing the final expression of everything contained in the nativity, also colour the mental outlook. Strong close aspects to the Ascendant affect the brain and severe afflictions can cause damage to this region.

Career

The nature of the native's employment is usually shown by the sign on the cusp of the tenth house, planets in the tenth or by the ruler of the tenth. Planets in strong close aspect to the Midheaven degree or any planet in a dominant position may have much effect upon the native's choice of career. The Sun, which is closely connected with what we *do*, may show the native's occupation by its sign or house position. The planet in closest aspect with the Sun sometimes indicates the vocation.

The majority distribution of planets in the triplicities and quadruplicities may also give a clue. The house ruled by a planet in the tenth, or the house position of the ruler of the tenth may also show the vocation.

Here is a guide to the occupations denoted by the signs (and corresponding houses) when they are connected with the tenth house:

ARIES. Engineering, politics, the armed forces, work requiring enterprise and initiative.

TAURUS. Farming, building, architecture, finance, banking, music; occupations involving set routine.

GEMINI. Transport, communications, journalism, agencies, teaching, publishing, printing, advertising, secretarial or clerical work; occupations involving travel and familiarity with a number of different environments.

CANCER. Commerce, catering, shopkeeping, hotel business, cookery, plumbing, laundry work, nursing, market gardening; occupations connected with the sea, liquids, with catering for public tastes or supplying domestic needs.

LEO. Public entertainment, stockbroking, company promoting, jewellery or cosmetics; occupations giving scope for creative work, organizing ability or self-exploitation.

VIRGO. Clerical or secretarial work, editing, teaching, chemistry, photography, nursing, medicine, physical culture, horticulture, grocery, food supplies, public hygiene, tailoring, haberdashery; occupations demanding technical or analytical skill or affording opportunities for service or patient application to detail, often in a subordinate capacity.

LIBRA. Art, politics, the Law, salesmanship, brokers, agents, fancy goods; occupations involving partnership and the adjusting of human relationships.

SCORPIO. The armed forces, police, surgery, banking, mining, undertaking, the meat trade, refrigeration, scientific research, brewing, work underground or connected with the sea, liquids or sanitation; work demanding determined effort and intense concentration.

SAGITTARIUS. Publicity, communications, the Law, the Church, lecturing, philosophy, travel, exploring, importing, foreign agencies; work where foresight and willingness to take a chance are assets.

CAPRICORN. Public administration, government service, politics; work calling for organizing ability, integrity and perseverance.

AQUARIUS. Work in public corporations, civil service, electricity, lecturing, water distribution; occupations allowing scope for inventiveness and the detached application of special rules and formulae.

PISCES. Nursing, medicine, work in hospitals, prisons, asylums, or connected with large animals, films, footwear, alcohol, the sea, cloth and woollen goods, oil.

Signs and houses often act through their polar opposite, so that actors sometimes have Aquarius strongly tenanted (not Leo) and a strong eleventh (not fifth) house. A double sign on the Midheaven may mean two simultaneous occupations or a number of changes of occupation. The second house (income) and the sixth (duty) also have some effect upon the choice of career.

The native's occupation is likely to have a connection with those things denoted by planets in the tenth or closely aspecting the Midheaven. The ruler of the Ascendant well aspected in the tenth denotes a rise in life.

Income

This is governed primarily by the second house, planets therein and the aspects to them, the sign on the cusp, aspects to the cusp and to the ruler of the second house. A good aspect to a planet in the second or to the ruler of the second from a planet in the fifth, shows the possibility of gain through speculation. A bad aspect from the ninth may show the possibility of losses abroad, and so on.

A healthy financial situation is shown by the benefics well placed by sign, angular and well aspected, especially if the Moon is involved; by favourable aspects to Jupiter from the heavier planets, and by a good aspect between the luminaries. A good aspect from Saturn to a prominent Jupiter may show permanent wealth.

A bad aspect from Saturn to the Moon, especially when either body is angular or Saturn or another afflicting malefic is elevated above the Moon, can cause great difficulty in obtaining sufficient money. Many planets in the second house show gains or losses from various sources. Mercury there well aspected by the benefics shows the earning of money through good abilities. Cardinal signs on the second cusp suggest an ambitious attitude towards financial matters; fixed signs the opportunity of a fixed income (often through investments) and mutable signs a fluctuating income, sometimes from more than one source. Speculation is ruled by the fifth and inheritance by the eighth house.

Health

The sixth and eighth houses have much to do with health and the signs on these cusps usually indicate vulnerable areas of the body. Generally speaking, the parts of the body ruled by the signs are also ruled by the corresponding houses.

The greatest threat to health is from an angular malefic that afflicts both luminaries. Afflictions tend to work out by polarity. Any cardinal afflictions may affect the head, stomach, kidneys and bones; fixed afflictions the throat, heart, trunk, genitals and circulation; mutable afflictions the nerves, lungs, limbs and bowels.

Afflictions to the Sun show constitutional and hereditary weaknesses; to the Moon, functional disorders arising after birth. Lunar afflictions are critical in childhood. Aspects from the benefics to the Ascendant and the luminaries are a great help in overcoming afflictions from the malefics, though much will depend on the relative strength of each. Rising malefics afflicting the Sun or Moon, or the luminaries or ruler of the Ascendant afflicted in the sixth, eighth or twelfth houses may bring prolonged ill health.

Mars by affliction brings fevers, cuts, burns, scalds, wounds and overactivity; Saturn, falls, chills, sluggish activity, sprains, dislocations and bruising; Uranus, excessive vitality, nervous tension, cramps, strictures, paroxysms, paralysis; Neptune, hypersensitivity, wasting, coma, hypochondriac tendencies; Pluto, eliminative disorders, deep-seated toxic conditions.

Good health results from a Moon that is free from affliction, well aspected by Jupiter and Venus, when the Ascendant is not tenanted or afflicted by the malefics.

Although the beginner may be able to estimate the potentialities of a nativity in relation to health and disease, he should bear in mind that medical astrology is a complex subject, requiring specialized medical knowledge if the best results are to be obtained.

Love and Marriage

The condition of Venus by sign and aspect shows the extent to which the native is able to live in harmony with a partner. The seventh house is the house of partnership and marriage and the sign on the cusp, its ruler, or any planet therein may describe the nature of the partner.

Symbolically, a man comes to terms with the female side of life through his wife. The Moon and Venus are general significators of women, hence strong afflictions to these bodies can either deny

marriage (especially if Saturn is involved), delay it or cause troubles in the marriage relationship.

The Sun and Mars represent the male principle and it is to the condition of these bodies that we look for indications of marriage in a female nativity. When these bodies or the seventh cusp are much afflicted, marriage may be denied or difficult to bring about.

When Saturnian contacts do not bring delay they are apt to show marriage to an older partner. Uranian aspects are often disruptive, causing sudden attractions or repulsions to arise with disconcerting effects upon relationships. Venus afflicted by Uranus but well aspected by Saturn can show separation without the marriage being dissolved.

Those with Venus in aspect to Mars usually wed. An aspect between the luminaries is also likely to show marriage. As the majority of people marry it is advisable to anticipate that the native will do so unless there are strong indications to the contrary.

Women are likely to marry if they are born with the Sun aspecting Mars; men, with the Moon aspecting Venus. A good aspect between the rulers of the Ascendant and seventh house is a good augury for marriage. Aspects to the Part of Marriage show whether the partnership is likely to be a happy one. The formula for calculating this Part is: Longitude of Ascendant + Longitude of Descendant − Longitude of Venus.

Love affairs are ruled by the fifth house and planets in the fifth and the ruler of the fifth show how love affairs are likely to prosper. A good aspect between planets in the fifth and seventh houses or between the rulers of these houses greatly assist the native's love life; the reverse when there are bad aspects.

Significators of marriage in multiple signs may denote several marriages. When Mars and Saturn are together concerned in the indications, marriage may be to a widow or widower.

Venus retrograde in a man's nativity may cause him to avoid women; similarly, a woman with Mars retrograde may seek to avoid men. The first application of the Moon in a male geniture and of the Sun in a female geniture on the days after birth to a planet within orbs of an aspect at birth show the circumstances of the marriage and sometimes indicate the type of partner. Application to a retrograde planet may denote difficulties or show an attachment that is broken. When the appropriate luminary makes no application to a planet before leaving the sign it is in, marriage may be denied.

Children

It is not advisable to judge whether the native will become a parent solely on the testimony of his or her own horoscope. One horoscope may combine with another to increase the probability of fruitfulness.

The condition of the Moon is all important. The fifth house, as the creative index of the nativity, must also be considered. See whether the Moon, planets in the fifth and the planet ruling the fifth are in fruitful signs. Water signs are the most fruitful, Aries, Leo and Capricorn least. Gemini and Sagittarius may produce twins but are otherwise not particularly fruitful; the other signs are moderately so. Fruitfulness is increased by aspects from Venus and Jupiter; diminished by the Sun, Mars and Saturn. Malefics in the fifth may not deny children but can cause them to be troublesome or difficult to rear. In a female nativity the applications of the Moon before leaving the sign it is in show possible offspring. If it makes no application, the possibility of offspring is diminished. The Sun afflicted by Saturn and in a barren sign is an indication of childlessness in a female nativity. A prominent Saturn in a male horoscope afflicting the Moon and Venus may denote sterility.

Judgement of the sex of children may be a somewhat tricky matter. In general, a majority of significators in masculine signs (♈, ♊, ♌, ♎, ♐, ♒) shows male offspring; in feminine signs, (♉, ♋, ♍, ♏, ♑, ♓) female offspring. Complications arise when feminine planets are in masculine signs.

Parents

The general significators of the father are the Sun and Saturn, of the mother, the Moon and Venus. If these bodies are much afflicted it may denote trouble involving the parents or they may be unsympathetic towards the native. Favourable aspects between the lights usually show a harmonious relationship between the parents.

The parents are also ruled by the fourth and tenth houses. The sign on the cusp of either house, planets therein and the condition of the house ruler indicate the native's attitude towards his parents, an attitude usually conditioned by their own circumstances and character, so that it is possible to a certain extent to suggest their natures and activities from the natus of their offspring.

There is no hard and fast rule as to whether the fourth or the tenth house rules the father. Sometimes the sign on the cusp appears to represent one parent, the planet tenanting the house, the other. The

parent most responsible for establishing the domestic atmosphere is probably shown by the fourth house, the parent who does most to foster the native's ambitions, by the tenth.

Travel

Although theoretically the third house represents short and the ninth long journeys, in practice it will be found that there is little difference. Those with the Moon in aspect to Mercury are most likely to travel, for their basic restlessness keeps them on the move. This tendency is much diminished when these bodies are in fixed signs. Much travel is likely when Mercury and the Moon are configured with Uranus, Neptune or Pluto, or when they are in a T-square with Jupiter, and many planets are in mutable or watery signs. Uranus, Neptune or Pluto in the fourth house sometimes denotes one who is constantly on the move. Saturn in the fourth shows that the native prefers to stay put. Afflicted planets in the travel houses may show dangers while travelling. If there are malefic planets on the angles of the nativity, a change of residence may be desirable. A congenial locality should be that which brings the benefics on to the angles of the horoscope when it is recalculated for the latitude and longitude of the new residence. A comparison of the birth horoscope with the horoscope of a place will often indicate whether that place will benefit the native. If the condition of the ninth house is very much better than that of the fourth, residence abroad might be advisable.

Friends and Enemies

Generally speaking, planets well placed by sign and favourably aspecting the luminaries or the ruler of the Ascendant represent friends; those badly placed and afflicting these bodies may represent potential enemies. Afflictions from Neptune are likely to indicate treachery and deceit, while a blend of Uranus and Mars in affliction usually indicates an uncompromising opponent. An afflicted Mars may denote difficulties with natives of Aries and Scorpio, and so on; similarly, well-aspected planets indicate the possibility of beneficial relationships with natives of the sign ruled by those planets.

Those dates during the year when the Sun is in good aspect with a well-placed planet in the nativity show the birth dates of possible friends; days when the Sun is in adverse aspect to planets badly placed in the natus show the birthdays of those who may be antagonistic. A satellitium in a sign may bring frequent contacts with the natives of that sign.

A well-aspected eleventh house shows the ability to make and keep friends. Afflictions involving the eleventh show either separations from friends, unfortunate friends or an inability to choose friends wisely. Good aspects from a planet in or ruling the eleventh to a planet in or ruling the tenth may show help from friends in the career. Judge similarly in the case of contacts involving the other houses. Malefics in the seventh may show an unfortunate approach to others that defeats the formation of settled friendships and occasionally arouses antagonism.

Death

The cause of death is usually shown by the eighth house and the circumstances in the closing years of life by the fourth house. An afflicted eighth house is likely to indicate death through illness or accident, whereas an afflicted fourth may denote difficult domestic conditions in old age. If the native dies young it is a moot point whether the fourth house indications apply.

Example Delineations

THIS is the nativity of a male (Figure 6). The first things we notice are the rising planet and luminary dominating a fairly well-integrated complex of planets linked by aspect. Only the Sun, Pluto, Jupiter and Saturn stand outside this complex. All the planets except Neptune and Pluto are in the North-East quadrant of the horoscope, showing that the native is able to give full rein to his instincts. The planets in this quadrant are all in the last four signs of the zodiac, which relate to universal concepts and ideas. The concentration of so many bodies within about 72° of the zodiac suggests a definite limitation of the deployment of the energies with some particular end in view, in this case an end related to demonstrating the universality of certain facets of human experience. The containing planets of this 72° arc are Uranus and Mercury – new means (Uranus) of communication (Mercury) and the quintile aspect of 72° (one-fifth of the zodiac) is strongly mercurial in its action.

The isolation of Neptune and Pluto in the Western hemisphere suggests that there is some heavily 'fated' side to the life and the subconscious awareness of this may play a dominating part in shaping the activities and attitudes of the native.

Counting the number of planets in each triplicity and quadruplicity we find that six are in mutables, two in cardinals and two in fixed; four are in air and two each in the remaining three elements. We thus get a majority in mutable and air signs. Gemini is the mutable air sign, ruled by Mercury, once again giving a similar emphasis. The final dispositor of all the planets is Saturn, accentuating the native's ambition and will to succeed.

Uranus, the planet nearest the Ascendant, is the ruler of the third house (communications) so that the native will be likely to regard himself as a special channel for the furtherance of all casual relationships. With Uranus is the Moon, ruling the eighth house, the house of regeneration and reorientation (and also death) indicating that the native may be the means of bringing about a change of attitude in relation to long-distance travel, philosophical concepts and exploration (Sagittarius). Sagittarius rises, indicating that the native presents himself to the world as someone seeking to establish widespread connections between all the fields of his experience. His spiritual aspira-

tions (fire) will be diffused in many different ways (mutable triplicity) and his search for enlightenment may lead him to seek many varied experiences and to travel widely or to investigate different philosophies and religions. His whole purpose in life will be centred

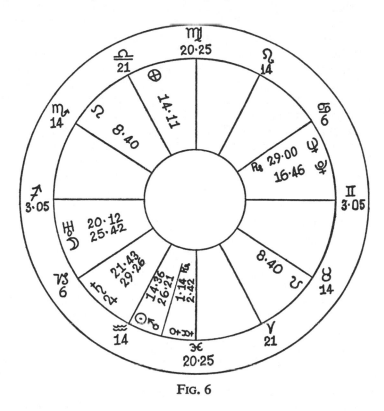

FIG. 6

around finding a suitable target at which to aim and accordingly his outward approach may be somewhat speculative. If the rest of the horoscope agrees, we may expect to find a spirited person of considerable optimism, inclined to be a little superficial and disjointed in his efforts.

The Moon rising in Sagittarius .aligns the native's feelings and instincts with the Sagittarian qualities already noted. The angular Moon shows that these feelings and instincts play a leading part in shaping the picture of himself that the native presents to the world. This is probably an individual who expresses his feelings freely and

spontaneously (Sagittarius). He will also make no attempt to conceal his various moods and through his emotional life he may make his main impact upon those around him. This lunar position increases the native's restlessness, receptiveness and intuition (especially in Sagittarius – although he may jump to conclusions too hastily). He could be very fond of travel. Sagittarius likes to propagate ideas and the Moon therein is often a feature in preachers' horoscopes, where the prophetic instinct of the sign is given full play.

Uranus also is rising, in conjunction with the Moon. We know that Uranus is the 'Awakener', stirring up in a dynamic way those things denoted by the sign tenanted and the planet or planets with which it is in aspect. We may therefore expect it to stimulate the liberty-loving side of Sagittarius, giving a hatred of restraint and making the feelings tense and powerful so that they could unbalance the whole psychological make-up unless other indications suggest that this side of the character is well integrated and held in check. Frustrations and limitations will be greatly resented and there may be some tendencies towards eccentricity or autocracy. The Moon rising in Sagittarius gives some ability to mix easily with all types of people but the conjunction of Uranus could limit this ability in some way or cause it to function excessively at spasmodic intervals. In this connection we may notice that the Midheaven, relating to the native's status in the community is squared by Uranus, indicating that erratic or unusual actions may affect the esteem in which he is held by his fellows. Note that the Moon is separating from the conjunction of Uranus, which is therefore throwing its rays forward to the Moon, perpetually arousing a desire to be free and untrammelled or, in the symbology of the sign, to soar like an arrow into the sky.

Mars in the third house is in sextile to the Moon and (very widely) to Uranus. The house containing Mars shows that department of life where the native's energies are mainly focused. The third house relates to the immediate environment where the native is able to make day to day contacts and observations based upon direct experience. It governs his practical everyday thinking and the way he deals with facts, thus the native thinks energetically and probably expresses himself forcefully. His energies are mainly devoted to coming to terms with his immediate environment. This position increases the likelihood of travel shown by the bodies rising in Sagittarius. The Martian energies are expressed through the sign Aquarius, giving a capacity for logical thinking and an inclination to seek theoretical explanations for phenomena. A fixed sign on the

third cusp increases the firmness of the native's ideas, tending to make him opinionated. The urge to originate is strong in Aquarius and all the native's powers of initiative will be harnessed to the task of sponsoring new and original concepts. To this end he may expect help from his natural ability to receive flashes of inspiration, shown by the rising Moon with Uranus in sextile to Mars. The wide Mars–Uranus sextile gains in importance as the Moon is in contact with both and Uranus disposes of Mars. This connection of Mars with the Moon–Uranus conjunction may increase any tendency to jump to conclusions somewhat dogmatically. There may be a special flair for establishing connections between hitherto unrelated concepts. The humanitarian qualities associated with Aquarius could be somewhat vitiated by the presence of Mars in the sign. Instead, Mars may feed the instinct for adventure and exploration sometimes associated with the Moon in Sagittarius and combine with Uranus to introduce a streak of ruthless assertiveness in the character.

Mercury in the third house increases the mental agility and means that the native expresses his powers of adaptability mainly in the realm of everyday contacts. There will be an aptitude for finding expedient solutions to the incidental problems that arise from day to day. With Mercury in Pisces, this faculty will operate over a wide field in a multiplicity of ways, giving either great resourcefulness or a vagueness that will prevent the best use of the sensitive impressionability this position brings. As Mercury is within orbs of a conjunction of Mars in Aquarius we can probably rule out the latter possibility. Pisces here may denote a breadth of outlook that mellows the thinking, an effect certainly enhanced by the conjunction of Venus with Mercury, which also focuses the native's desire to achieve harmony in the same sector of the horoscope. Pisces is the most universal of the signs and Mercury and Venus here suggest that the native is seeking to establish far-flung connections and introduce a widespread harmony into a number of everyday relationships. As Mars in Aquarius is also in the third house, there will be a tendency to propagate these ideas forcefully or in some highly practical manner. Venus and Mercury also fall in square to the Ascendant, emphasizing the restless tendencies already noted, for not only is Mercury the Messenger of the Gods, pictured with wings on his feet but he is in Pisces, the sign in which all boundaries are melted. The square of Venus to the Ascendant adds sympathy to the nature but any affliction from Pisces can indicate danger of involvement in sorrow or distress when this sign is unduly accentuated. Venus in contact with

the Ascendant will make the native more popular, however. This position may give some artistic appreciation, possibly a fondness for music and poetry.

Neptune representing the capacity for idealism, the powers of renunciation, of losing oneself in some greater issue, is in Gemini in the seventh house, the house that shows what we lack and the way in which we are inclined to look upon the world at large. Sometimes those with Neptune in the seventh renounce the world. The seventh house shows those whom we attract to ourselves because of our sense of lack and such people often personify the quality shown by the planet in the seventh. The native with Neptune in the seventh is sometimes misunderstood as those around him fail to register a clear picture of him. Often the native makes considerable efforts to compensate for the quality he lacks and his struggles to do so are projected on to the world outside himself. Neptune in Gemini shows that the native is conscious of a need to establish bonds of sympathy between neighbours (in the broadest sense) and to link together those elements in everyday life and in his near at hand environment that may be dissociated. Education and travel are the two activities usually linked with the sign. Mercury and Pisces and Neptune in Gemini are in mutual disposition and we have already noted the presence of three planets in the third house. There is thus a very strong accent on third house matters, together with a considerable emphasis on the opposite ninth house sign, Sagittarius, containing the Ascendant, Moon and Uranus. Thus the likelihood of the native being interested in travel, education and philosophy is becoming more and more certain.

Neptune opposes the rising Moon–Uranus conjunction and stands in trine to the Mercury–Venus–Mars conjunction in the third house, which thus mediates Neptune's opposition to the first house planets. The Neptunian rays will somewhat soften the rather hard sextile between the Moon–Uranus conjunction and Mars but there is a danger that the inflationary and self-exalting side of Neptune may also so expand the native's restlessness and rather dogmatic habits of thinking already noted that he will find it difficult to keep a due sense of proportion. He will need to see that he is not unduly influenced in his casual relationships (Gemini on the seventh cusp) otherwise such outside influence may interfere with his sense of perspective.

We have yet to consider two very important factors, the Sun and the ruler of the Ascendant, Jupiter. So far we have concerned our-

selves with the prominent complex of planets in the first, seventh and third houses. In other horoscopes it may be convenient to take stock of the Sun and the ruler at an earlier stage. The Sun in Aquarius reinforces the position of Mars in that sign and indicates the true inner urge of the native. The sphere of Aquarius is that of original thinking, the ability to perceive first principles and to realize the underlying brotherhood between all men. The Sun, falling on the third cusp, places a further and decisive emphasis upon the third house and all that it implies; the relationship between things near at hand as it can be established by the intellect, by travelling and mixing with large numbers of casual acquaintances and by the impact of large numbers of first hand impressions. The Sun in the third increases the breadth and generosity of the mind, strengthening the native's urge to express himself through his powers of communication. It increases his confidence in his own ideas and may make him too sure of his own infallibility. He will envisage his role in life as that of the builder of connections, the formulator of ideas – which will be all important to him. Operating through Aquarius, the solar impulse will tend to function in a detached manner, giving him the capacity to sum up a situation dispassionately.

Pluto in Gemini in the seventh house falls in trine to the Sun and in opposition to Uranus. The already decisive emphasis on the third house is further confirmed, intensified and strengthened by this aspect from Pluto in the third house sign, for Pluto intensifies to a critical degree the influence of the planets it aspects. From the seventh house, Pluto will act through the agency of other people. Their arguments (Gemini) will convince him of the rightness of his own ideas (Pluto trine third house Sun). The seventh house, governing the relationships between equals, is related to politics. Pluto representing the strength derived from people in the mass may cause the native to regard people in general as one great unit, to be integrated according to some special plan. Fortuna, which indicates the dominant emphasis in any horoscope by the planets which it most closely aspects completes a grand trine with the Sun and Pluto from the tenth house. This suggests that the native is compelled by a strong urge (Sun trine Pluto) to establish firm means of communication (Sun on third cusp; Pluto in Gemini) on a wide scale (Sun in Aquarius). His success in achieving this aim will directly affect his prestige (Fortuna in tenth).

Jupiter in the second house is in Capricorn, the sign of organization and achievement. It encourages a responsible attitude, in this

case to possessions and resources, the realm of the second house. The native's desire to expand (Jupiter) is taken as a serious responsibility (Capricorn) so that he will be inclined to husband his resources carefully. Such an attitude may well have been due to the father's example (Capricorn). In this horoscope, showing much determination (Sun in fixed sign trine Pluto) and an instinctive and rebellious love of freedom (Moon conjunct Uranus rising in Sagittarius) the sign placement of the ruler of the Ascendant (and the dispositor of the Moon and Uranus) brings an element of prudence into the character that may well ensure that other factors are kept within reasonable control. The only notable aspect to Jupiter is a close quincunx from Neptune, indicating that pressure from outside (Neptune in seventh) may occasionally bring about errors of judgement. The native may be asked to undertake more than he feels he can reasonably cope with.

Finally, we have to consider Saturn in Capricorn, also in the second house. Immediately we notice that Saturn in its own sign is close enough to Jupiter to overpower it to a large extent, decreasing its buoyancy (Jupiter is weak in Capricorn) and introducing a greater measure of caution in second house matters. The native will experience a feeling of lack (Saturn) in relation to his resources so that there will be a tendency to conserve them carefully and invest them wisely. He will be ambitious (Capricorn) to build up his resources on all levels and there will be less tendency to take physical risks than there would otherwise have been. Any risks taken will be 'calculated risks'. Saturn is also in trine to the Midheaven, giving stamina and persistence, and is semi-sextile Uranus and semi-sextile the Sun–Mars mid-point, giving a much needed measure of control over the physically adventurous spirit and the rather assertive mental outlook.

The horoscope we have been analysing is that of Colonel Charles Lindbergh, the first man to fly solo across the Atlantic. His long-distance flights captured the imagination of his contemporaries and opened up new possibilities for commercial aviation. The tragic kidnapping and death of his firstborn child shocked a nation. (♄ □ cusp 5; ♂ ≈ configured with ♅ and ♆; antiscion ♀ □ Fortuna). His advocacy of the policy that the United States should stand aside from World War Two (a repetition of his father's attitude to World War One – ♑ on cusp 2; ♄ in 2, conservation of resources) brought a sudden reversal of popularity (♅ □ M.C.) and his previous visits to Nazi Germany gave rise to charges that he was pro-Fascist (⊙ △ ♀; ☽ ♂ ♅). After Pearl Harbour he abandoned his isolationist

views and again joined the Air Corps in which he served with distinction.

He first met his wife, Ann Morrow Lindbergh in Mexico (☽ ♐ – foreign countries) while her father, Dwight Morrow, was U.S. ambassador there. She accompanied him on some of his long-distance flights after they were married and is well known as a writer and poet. The Moon applies to Mars in the third (writing, travel); Mercury rules the seventh and Neptune is in the seventh. Venus is in Pisces (poetry) and conjunct Mercury (writing, travel) ruler of the seventh. Pluto and Neptune in the seventh show the dramatic course of the early married life. The Lindberghs now have five children, three sons and two daughters (Asc. □ ♀ in fruitful sign Pisces; angular ☽ ⚹ ♂ ♒).

As a barn-storming pilot young Lindbergh's dare-devil exploits and stunts made his companions dive frequently for safety (☽ ☌ ♅ ♐ – horseplay!). He had great difficulty in getting sufficient financial backing for his Atlantic flight (♄ in 2) but won a substantial prize for his feat (♃ in 2).

After the murder of his child he sought a less troubled environment first in England, then in France, finally returning to the United States just before the outbreak of the war. (♅ □ I.C. – unsettled domestic environment.) While in Europe he collaborated with Alexis Carrel (author of *Man the Unknown* and for nearly thirty years on the staff of the Rockefeller Institute of Medical Research in New York) on the remote French island of Illiec in work on a so-called 'mechanical heart' that would enable organs separated from the parent body to live for indefinite periods (☉ ♒ – circulation – △ ♀; ♍ – health – on M.C.; ♂ ⚹ ♅ – mechanical ability).

The mutual disposition of ☿ ♓ and ♆ ♊ faithfully expresses itself in these words of Lindbergh's: 'We actually live today in our dreams of yesterday; and living in those dreams, we dream again.'

If we consider the various horoscopical factors in relation to the Moon's Nodes we find even more light thrown on the picture. Caput Draconis in Scorpio shows that the native's special task is to increase his determination, concentration and emotional control. The particular sphere in which these qualities are to be developed is shown by the position of Mars, the dispositor of the North Node, in the third house of travel and ideas, in trine to Neptune. The South Node in Taurus and its dispositor, Venus in Pisces, suggest a previous tendency to remain a passive dreamer of dreams. Through Neptune and its trine to Mars, this previous phase of experience is to

be utilized to add vision to the more vigorous activities of the present incarnation. Neptune and Pluto are isolated by nodal hemisphere, just as they are by the meridian axis, tremendously accentuating the effect of these great forces upon the life.

We can express the planets and angles in terms of a lunar zodiac beginning with the Moon's North Node, which for the purposes of this special relationship we can regard as representing 0° Aries. To do this we simply add to all factors the amount of arc necessary to bring 8° ♎ 40' to 0°♈ (i.e. 4 signs 21° 20'). The build-up thus obtained between the old and new positions shows how the legacy of the past affects the life-pattern of the present. The following cross-aspects speak for themselves:—

New Positions		Aspects to Natal Positions
♀	8 ♎ 06	♂ ♌
M.C.	11 ♒ 45	♂ ☉
♄	13 ♊ 03	♂ ♀△ ☉
⊕	5 ♓ 31	♂ ☿
Asc.	24 ♈ 25	△ ☽ ⚹ ♂
♅	11 ♉ 32 ⎱	☐ ☉
☽	17 ♉ 02 ⎰	
♂	17 ♋ 41 ⎱	☍ ♄
♀	22 ♋ 34 ⎰	
♆	20 ♏ 20	☐ ☉/♂ ⚹ ♄

In the nativity of Marilyn Monroe (Figure 7) the planet of Glamour (Neptune) rises in the sign of showmanship (Leo) in trine to the planet of Beauty (Venus) on the cusp of and ruling the house of career. Mars, ruling the Midheaven, is in Pisces (Films) and the Sun and its dispositor are in the eleventh house, which with the fifth forms the sector related to show business. Marilyn's parents separated as soon as she was born, abandoning her to the tender care of an orphanage (Saturn intercepted in fourth, heredity, home life, square Moon, Jupiter and Neptune; Fortuna square Pluto in Cancer) and before she was nine she was looked after by eleven different families, all abjectly poor, each with a different set of moral values. Such a variety of conflicting moral standards (Saturn square Neptune) must have occasioned considerable confusion in her young mind and conditioned her philosophical outlook (Pisces on ninth), implanting a vigorous desire (Mars conjunct Uranus trine

Saturn) to escape from the sordid side of life (Pisces). 'Looking back', she said, 'I guess I used to play act all the time.' (Neptune rising in

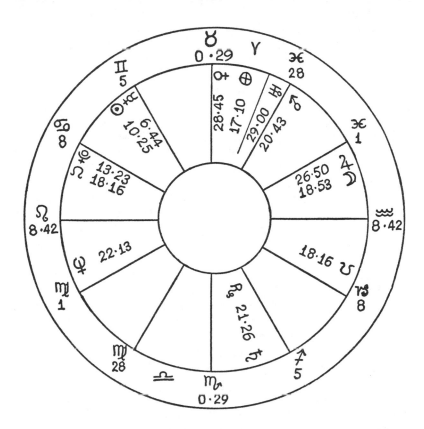

FIG. 7 Marilyn Monroe, 1st June, 1926 9.09 a.m. P.S.T., Los Angeles

Leo; Sun in eleventh). Her precipitate first marriage at sixteen was largely due to her desire to escape from uncongenial conditions.

Mars in Pisces quincunx Neptune did not help permanent relationships with the opposite sex; three marriages were dissolved. Both Sun and Mars are in dual signs and Venus is semi-sextile Uranus from an uncongenial sign. Her third husband, Arthur Miller, was a brilliant writer (Sun in Gemini; Mercury trine

seventh). Her earning capacity was high (Moon conjunct Jupiter trine Sun; Jupiter on eighth cusp; Venus trine second). Her unpunctuality was something of a legend (Saturn afflicted, Neptune rising). She had no children (Moon first applies to square of afflicted Saturn). During the war, before her screen career, she worked as a parachute (Neptune) inspector (Saturn in Scorpio) and a paint sprayer (Mars, dispositor of ruler of tenth in Pisces – diffusion – conjunct Uranus – labour saving devices).

She had (says a leading critic) a phenomenal degree of responsiveness and the greatest sensitivity (Neptune rising trine Venus; Mars conjunct Uranus in Pisces). The majority of planets above the horizon show her strong impact upon the world at large, the Neptune–Saturn square isolated below the horizon, the many psychological problems occasioned by her grim and miserable experiences in early life.

An analysis of the various horoscopical factors in relation to the Moon's Nodes brings an even sharper focus to bear upon the Saturn-Neptune square, for these are the only two planets in the "eastern" nodal hemisphere. Furthermore, Saturn is the dispositor of the South Node and shows by its afflicted condition, a previous life where the native was faced with extremely difficult and involved problems of self-discipline. The Moon, the dispositor of the North Node, showing the work to be done during the present life, applies to the square of Saturn and the opposition of Neptune, suggesting that the whole life experience will be orientated in such a way as to bear on the problem of straightening out this particular legacy of the past. The placement of the nodes midway between Mars and Saturn is a further severe affliction. The Moon, and the North Node in the twelfth house, relating to the native's final adjustment to life, show the crucial nature of the problems with which she had to contend. The development of emotional sensitivity (♌ in ♋) is shown as an important factor in this struggle.

If we translate the planetary and angular positions to the lunar zodiac, even more significant stresses become apparent:—

	New Positions	Aspects to Natal Positions
♀	25 ♓ 07	☌ ♂/♅
☉	22 ♒ 09	☌ ☽/♃□ ♄ ☍ ♆
M.C.	12 ♑ 13	☍ ♂
⊕	28 ♐ 53	□ ♅

♅ 10 ♐ 44 ☍ ☉
♌ 0 ♈ ☌ ♅
☽ 0 ♍ 36 ☍ M.C.
♆ 3 ♉ 57 ☌ M.C.
♀ 10 ♑ 29 ☍ ♀

Her unfortunate death from an overdose of drugs in circumstances which suggested suicide is a sad testimony to the power of the Saturn-Neptune square, which seems to have dominated the life. Suicide usually results from a strong death wish (♄ ♍ afflicted in 4th; ⊕ ♈ □ ♀), coupled with an over-accentuated desire for self-surrender (♆ in 1st afflicted), plus a considerable element of desperation (♂☌ ♅). The Sun's applying square to Mars, although apparently very weak, also enters into this pattern, for on the days after birth the square is drawing ever closer.

CHAPTER TEN

Conclusion

IN the foregoing pages it has only been possible to introduce the student to some aspects of natal astrology. There has not been room, for instance, to deal with the complicated matter of prediction or to make mention of other branches of the art, such as mundane, horary and electional astrology, to name but three. As the reader progresses in his studies and widens the field of his investigations, he will no doubt encounter problems and discover controversial issues that are not easily resolved. Such problems and controversies, although they may hint that our knowledge of the science is by no means as complete as we would wish, indicate that astrology is a living thing and a perpetual challenge to the ingenuity and understanding of its practitioners.

The student will probably find that many of his problems can be placed in truer perspective if he has the opportunity to contact other students and discuss his ideas with them. Listed below are organizations you can contact to learn astrology and publications that are well worth reading. Finding a good teacher can save the new student years of wasted effort and prevent many dead-end lines of pursuit.

ORGANIZATIONS

Sacramento Astrology Group
c/o Gavin Carruthers
1221 25th Street, #E
Sacramento, CA 95816

Ongoing classes and occasional workshops.

Faculty of Astrological Studies
Central Office
29(A) Sussex Road
Haywards Heath
England RH16 4DZ

Has a long established correspondence course.

NCGR New York
c/o John Marchesella
152 7th Avenue, #3F
New York, NY 10011

Holds ongoing classes and workshops.

Mayo School of Astrology
Dept. P1
8 Stoggy Lane
Plympton, Plymouth, Devon
England

Has a well-respected correspondence course.

Aquarius Workshops
P. O. Box 556
Encino, CA 91426

NCGR
5826 Greensprings Avenue
Baltimore, MD 21209

Has many local chapters which have classes.

UFAN
c/o Lilian Huber
14840 Birmingham Avenue
Alpharetta, GA 30201

May be able to put you in touch with a teacher in your area.

PUBLICATIONS

Write the specific publications for a sample copy and subscription rate.

"Fraternity News" — Journal of the Fraternity of Canadian Astrologers
Nancy Atwood, membership secretary
13155 24th Avenue
Surrey, B.C.
Canada V4A 2G2

"Aspects" Magazine
Aquarius Workshops Inc.
P. O. Box 556
Encino, CA 91426

"Kosmos" — The Journal of ISAR
P. O. Box 38613
Los Angeles, CA 90038

The New Astrologer
SB Publications
65 Chilkwell Street
Glastonbury
Somerset BA6 8DD England

"Welcome to Planet Earth"
P. O. Box 5164
Eugene, OR 97405

Astrological Assn. Journal
Margaret Hunter
21 Farley Hill
Luton, Beds
England LU1 5EE

"Considerations"
P. O. Box 491
Mount Kisco, NY 10549

Finally, a word about the ethics of astrology. In a properly ordered society the astrologer should be in much the same position as a doctor, psychologist or priest. Indeed, in ancient Egypt and Babylonia, priests were true healers, well versed in astrology, skilled in medicine and fully conversant with the workings of the psyche. Although this state of affairs does not obtain today, the proficient astrologer may some-

times be called upon to help those of his fellow beings who have difficult personal problems to solve. In such circumstances he should recognize that his position is a privileged one and that the possession of astrological knowledge is a trust not to be regarded lightly. He should refrain from giving advice unless it is asked for and then he should always try to suggest to those seeking help how they can best help themselves, by dwelling upon the strengths and not the weaknesses of the horoscope and by drawing attention to such favorable opportunities for development that must sooner or later present themselves, so that present difficulties may better be placed in perspective. *Never attempt to delineate or predict in too much detail,* for to do so successfully requires a most unusual degree of inspiration. Above all, never suggest the time when death is likely to take place as this must inevitably cause an unfavorable psychological reaction even in the minds of those who believe themselves capable of contemplating such information with the utmost detachment. It goes without saying that the astrologer should never divulge information given to him in confidence nor should he spend too much time and energy seeking to turn his astrological knowledge to financial profit.

However chaotic the external conditions of life may be, it is difficult for the student who has gained some first-hand knowledge of the workings of astrology to escape the conclusion that we live in an ordered world and that astrology provides a major key to the understanding of the higher laws that govern the universe. The degree of understanding that the student will be able to bring to bear upon the interpretation of horoscopes will therefore depend upon his knowledge of these laws, so that he should strive to develop and expand his knowledge of metaphysical and occult philosophy to the full extent of which he is capable, not only in order to gain the fullest possible understanding of the science and of himself, but also in order to fit himself to make the best possible use of such knowledge for the benefit of his fellow human beings.

Appendix

RECOMMENDED FURTHER READING

Astrology—Your Place among the Stars, Evangeline Adams.

The Astrological Aspects, C. E. O. Carter, L. N. Fowler & Co., Ltd.

Some Principles of Horoscopic Delineation, C. E. O. Carter.

Essays on the Foundations of Astrology, C. E. O. Carter, Theosophical Publishing House.

An Introduction of Political Astrology, C. E. O. Carter, L. N. Fowler & Co., Ltd.

The Technique of Prediction, R. C. Davison, L. N. Fowler & Co., Ltd.

Synastry: Understanding Human Relations through Astrology, R. C. Davison, Aurora Pubns.

Astrology—How and Why It Works, Marc Edmund Jones, Shambhala Pubns.

The Guide to Horoscope Interpretation, Marc Edmund Jones, Shambhala Pubns.

Signs of the Zodiac Analyzed, Isabelle M. Pagan, The Theosophical Publishing House.

The Pulse of Life, Dane Rudhyar.

NOTE

Before setting up a horoscope you will need the following:

Accurate birth data
An ephemeris listing planetary positions
A Table of Houses
A book of Time Changes in the country of birth

171

A complete Atlas or Longitude & Latitude reference book
& competent mathematical ability.

Since purchasing so many large reference books* will involve a con-
siderable cash outlay, it is advisable that new students of astrology usu-
ally begin by having a few charts done by a competent computer-chart
service.

IMPORTANT WARNING: For truly serious students of astrology,
it will be necessary eventually to learn the method of accurate chart
calculation. But realistically, few learn it accurately on their own.
Without the guidance of a good teacher or helpful metaphysical
bookstore, it is likely that most charts calculated by self-taught methods
will be in error, often substantially so.

Therefore, unless one has such a teacher, it is strongly recommended
that the new student procure a chart from one of the calculation ser-
vices that specialize in such work. In our experience, the necessary
expertise and reference materials exist at the following firm which
calculates basic natal charts for a very low fee. However, we would
urge beginners to order just the chart that contains the *basic planets
only*—not the asteroids, vertex, or other recently fashionable minor
details:

<div align="center">

ACS
P. O. Box 16430
San Diego, CA 92116

</div>

*SOURCES FOR THESE BOOKS: General bookstores will rarely have any of the books
mentioned above. Try a local "New Age" or metaphysical bookstore or write the following
shops for their mail order catalogs: Astrology Et Al, 4728 University Way N. E.,
Seattle, WA 98105 or Astrology & Spiritual Center, 4535 Hohman Ave., Hammond,
IN 46327.

Index

(Explanations of terms in *italics* are given on the page indicated.)

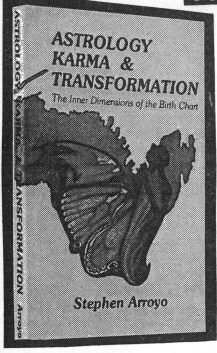

CRCS Books

THE ANCIENT SCIENCE OF GEOMANCY:Living in Harmony with the Earth by Nigel Pennick $12.95. The best and most accessible survey of this ancient wholistic art/science, superbly illustrated with 120 photos.

AN ASTROLOGICAL GUIDE TO SELF-AWARENESS by Donna Cunningham, M.S.W. $6.95. Written in a lively style, this book includes chapters on transits, houses, interpreting aspects, etc A popular book translated into 5 languages.

THE ART OF CHART INTERPRETATION: A Step-by-Step Method of Analyzing,Synthesizing & Understanding the Birth Chart by Tracy Marks $7.95. A guide to determining the most important features of a birth chart. A must for students!

THE ASTROLOGER'S GUIDE TO COUNSELING: Astrology's Role in the Helping Professions by Bernard Rosenblum, M.D. $7.95. Establishes astrological counseling as a valid and legitimate helping profession. A break-through book!

THE ASTROLOGER'S MANUAL: Modern Insights into an Ancient Art by Landis Knight Green $10.95, 240 pages. A strikingly original work that includes extensive sections on relationships, aspects, and all the fundamentals in a lively new way.

THE ASTROLOGICAL HOUSES: The Spectrum of Individual Experience by Dane Rudhyar $8.95. A recognized classic of modern astrology that has sold over 100,000 copies, this book is required reading for every student of astrology seeking to understand the deeper meanings of the houses.

ASTROLOGY: The Classic Guide to Understanding Your Horoscope by Ronald C. Davison $7.95. The most popular book on astrology during the 1960's & 1970's is now back in print in a new edition, with an instructive new foreword that explains how the author's remarkable keyword system can be used by even the novice student of astrology.

ASTROLOGY FOR THE NEW AGE: An Intuitive Approach by Marcus Allen $7.95. Emphasizes self-acceptance and tuning in to your chart with a positive openness. Helps one create his or her own interpretation.

ASTROLOGY IN MODERN LANGUAGE by Richard Vaughan $12.95, 336 pages. An in-depth inter-pretation of the birth chart focusing on the houses and their ruling planets-- including the Ascendant and its ruler. A unique, strikingly original work.

ASTROLOGY, KARMA & TRANSFORMATION: The Inner Dimensions of the Birth Chart by Stephen Arroyo $10.95. An insightful book on the use of astrology for persoal growth, seen in the light of the theory of karma and the urge toward self-transformation. International best-seller!

THE ASTROLOGY OF SELF-DISCOVERY: An In-Depth Exploration of the Potentials Revealed in Your Birth Chart by Tracy Marks $8.95, 288 pages. Emphasizes the Moon and its nodes, Neptune, Pluto, & the outer planet transits. An important and brilliantly original work!

ASTROLOGY, PSYCHOLOGY AND THE FOUR ELEMENTS: An Energy Approach to Astrology & Its Use in the Counseling Arts by Stephen Arroyo $7.95. An international best-seller, this book deals with the use of astrology as a practical method of understanding one's attunement to universal forces. Clearly shows how to approach astrology with a real understanding of the energies involved. Awarded the British Astrological Assn's Astrology Prize. A classic translated into 8 languages!

CYCLES OF BECOMING: The Planetary Pattern of Growth by Alexander Ruperti $12.95, 274 pages. The first complete treatment of transits from a humanistic and holistic perspective. All important planetary cycles are correlated with the essential phases of personal development. A pioneering work!

DYNAMICS OF ASPECT ANALYSIS: New Perceptions in Astrology by Bil Tierney $8.95, 288 pages. Ground-breaking work! The most in-depth treatment of aspects and aspect patterns available, including both major and minor configurations. Also includes retrogrades, unaspected planets & more!

A JOURNEY THROUGH THE BIRTH CHART: Using Astrology on Your Life Path by Joanne Wickenburg $7.95. Gives the reader the tools to put the pieces of the birth chart together for self-understanding and encourages creative interpretation by helping the reader to think through the endless combinations of astrological symbols.

THE JUPITER/SATURN CONFERENCE LECTURES: New Insights in Modern Astrology by Stephen Arroyo & Liz Greene $8.95. Talks included deal with myth, chart synthesis, relationships, & Jungian psychology related to astrology. A wealth of original & important ideas!

THE LITERARY ZODIAC by Paul Wright $12.95, 240 pages. A pioneering work, based on extensive research, exploring the connection between astrology and literary creativity.

LOOKING AT ASTROLOGY by Liz Greene $7.50. A beautiful, full-color children's book for ages 6-13. Illustrated by the author, this is the best explanation of astrology for children and was highly recommended by SCHOOL LIBRARY JOURNAL. Emphasizes self-acceptance and a realistic understanding of others.

NUMBERS AS SYMBOLS FOR SELF-DISCOVERY: Exploring Character & Destiny with Numerology by Richard Vaughan $8.95, 336 pages. A how-to book on personal analysis and forecasting your future through Numerology. Examples include the number patterns of a thousand famous personalities.

THE OUTER PLANETS & THEIR CYCLES: The Astrology of the Collective by Liz Greene $7.95. Deals with the individual's attunement to the outer planets as well as with significant historical and generational trends that correlate to these planetary cycles.

PLANETARY ASPECTS: FROM CONFLICT TO COOPERATION: How to Make Your Stressful Aspects Work for You by Tracy Marks $8.95, 225 pages. This revised edition of HOW TO HANDLE YOUR T-SQUARE focuses on the creative understanding of the stressful aspects and focuses on the T-Square configuration both in natal charts and as formed by transits & progressions. The most thorough treatment of these subjects in print!

THE PLANETS AND HUMAN BEHAVIOR by Jeff Mayo $7.95. A pioneering exploration of the symbolism of the planets, blending their modern psychological significance with their ancient mythological meanings. Includes many tips on interpretation.

PRACTICAL PALMISTRY: A Positive Approach from a Modern Perspective by David Brandon-Jones $8.95, 268 pages. This easy-to-use book describes and illustrates all the basics of traditional palmistry and then builds upon that with more recent discoveries based upon the author's extensive experience and case studies. A discriminating approach to an ancient science that includes many original ideas!

THE PRACTICE AND PROFESSION OF ASTROLOGY: Rebuilding Our Lost Connections with the Cosmos by Stephen Arroyo $7.95. A challenging, often controversial treatment of astrology's place in modern society and of astrological counseling as both a legitimate profession and a healing process.

REINCARNATION THROUGH THE ZODIAC by Joan Hodgson $6.50. A study of the signs of the zodiac from a spiritual perspective, based upon the development of different phases of conciousness through reincarnation.

RELATIONSHIPS & LIFE CYCLES: Modern Dimensions of Astrology by Stephen Arroyo $8.95. Thorough discussion of natal chart indicators of one's capacity and need for relationship; techniques of chart comparison; using transits practically; and the use of the houses in chart comparison.

SEX & THE ZODIAC: An Astrological Guide to Intimate Relationships by Helen Terrell $7.95, 256 pages. Goes into great detail in describing and analyzing the dominant traits of women and men as indicated by their Zodiacal signs.

THE SPIRAL OF LIFE: Unlocking Your Potential with Astrology by Joanne Wickenburg & Virginia Meyer $7.95. Covering all astrological factors, this book shows how understanding the birth pattern is an exciting path toward increased self-awareness.

A SPIRITUAL APPROACH TO ASTROLOGY: A Complete Textbook of Astrology by Myrna Lofthus $12.95, 444 pages. A complete astrology textbook from a karmic viewpoint, with an especially valuable 130-page section on karmic interpretation of all aspects, including the Ascendant & MC.

For more complete information on our books, a complete booklist, or to order any of the above publications, WRITE TO:

CRCS Publications
Post Office Box 1460
Sebastopol, California 95473
U.S.A.

ASTROLOGY, PSYCHOLOGY,

AND

THE FOUR ELEMENTS

An Energy Approach to Astrology &
Its Use in the Counseling Arts

Stephen Arroyo

$9.95

This book deals with the relation of astrology to modern psychology and with the use of astrology as a practical method of understanding one's attunement to universal forces. It clearly shows how to approach astrology with a real understanding of the energies involved, and it includes practical instruction in the interpretation of astrological factors with more depth than is commonly found in astrological textbooks. Part I was awarded the 1973 Astrology Prize by the British Astrological Association as the most valuable contribution to astrology during that year.

PART I: ASTROLOGY & PSYCHOLOGY

Part I thoroughly explains how astrology can be the most valuable psychological tool for understanding oneself and others. Analyzing the scientific, philosophical, and intuitive dimensions of astrology, it is oriented toward the layman with no astrological knowledge, astrology students and professionals, and those engaged in any form of the counseling arts.

PART II: THE FOUR ELEMENTS
AN ENERGY APPROACH TO INTERPRETING
BIRTH-CHARTS

Part II deals specifically with the interpretation and practical application of astrological factors based on the actual energies involved (air, fire, water, & earth). It presents a dynamic application of astrological knowledge that clarifies and illuminates traditional techniques and meanings by placing them in the perspective of understanding the vital energies inherent in all life processes.

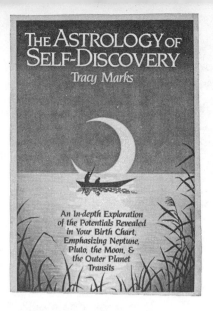

A JOURNEY THROUGH THE BIRTH CHART: Using
Astrology on Your Life Path$7.95
by Joanne Wickenburg, 168 pages. An
excellent introduction to astrological
basics with a modern slant, in which the
author gives the reader the tools to put
the pieces of a birth chart together for
self-understanding, rather than relying
on traditional "cookbook" interpretations.
This book is a journey that carries the
reader through continual discoveries of
what the planets, signs, and houses mean
in his or her particular birth chart.

THE ASTROLOGY OF SELF-DISCOVERY: An In-Depth
Exploration of the Potentials Revealed in Your
Birth Chart by Tracy Marks, $8.95...240 pages.
A guide for utilizing astrology to aid self-
development, resolve inner conflicts, discover
and fulfill one's life purpose, and realize
one's potential. In modern language, the author
explains how the Moon and the outer planets
reveal potentials for self-discovery and
personal growth at an especially deep level.